PARK GÜELL

Gaudí's Utopia

TEXT
Josep M. Carandell

PHOTOGRAPHY
Pere Vivas

TRIANGLE ▼ POSTALS

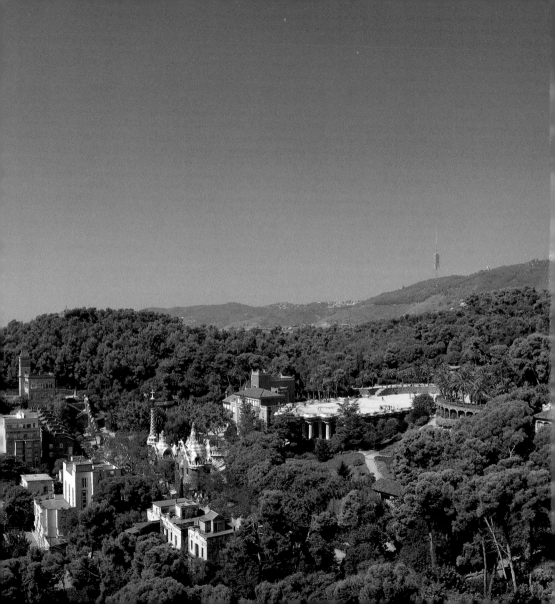

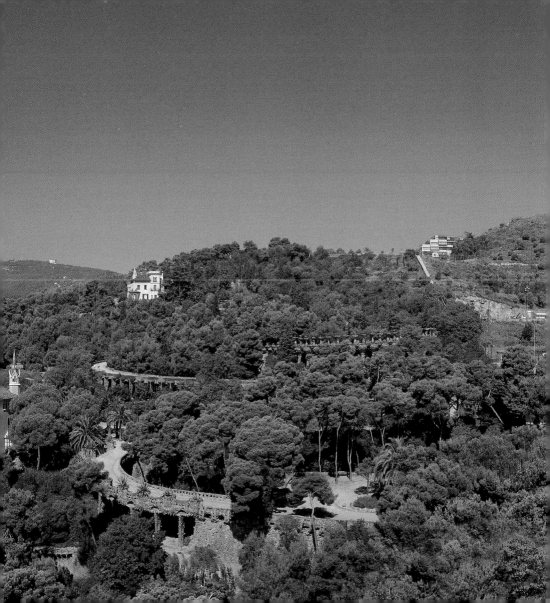

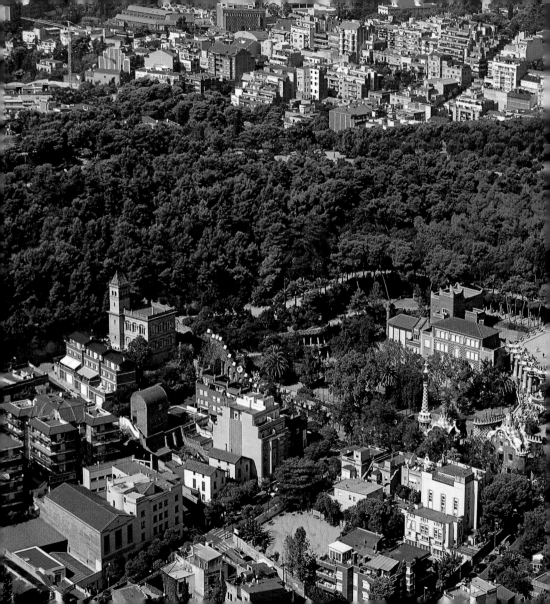

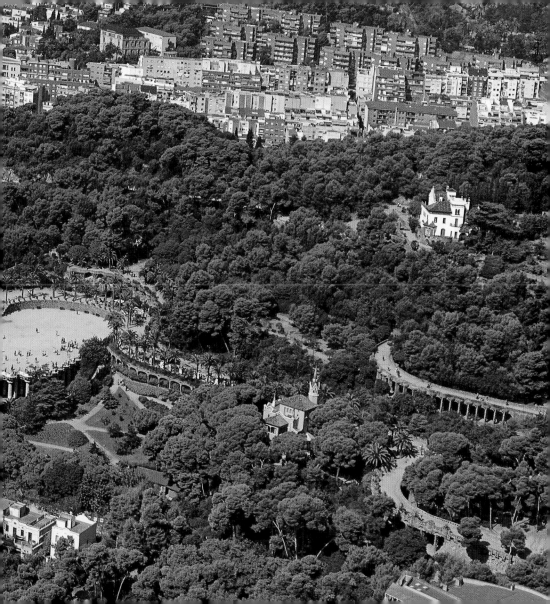

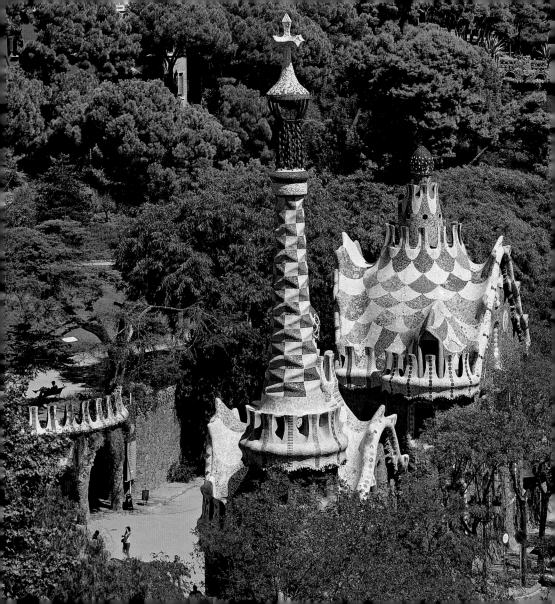

CONTENTS

PARK GÜELL
Gaudí's Utopia

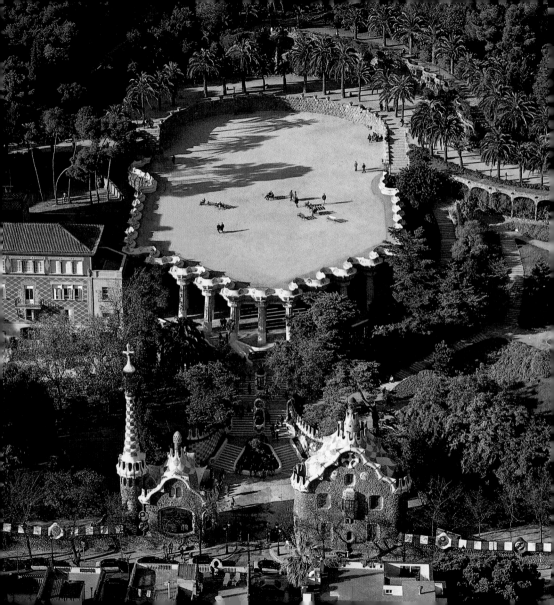

THE PLACE AND THE LEGEND

Before Barcelona lies the sea, and behind it rises the Collserola range, reaching its highest point in mount Tibidabo presiding over the city. The Can Muntaner estate which industrialist and patron of the arts, Eusebi Güell, decided to acquire was situated on the outlying Muntanya Pelada or Bald Mountain. Güell's objective in doing so was to create a park that would be unique of its kind.

Formerly it was common practice for Catholics to be guided in their decisions by the communion of saints and their days. Thus it was that in 1899, Güell signed the contract to buy the estate on the 29th of June, Saint Martha's day. Martha (the sister of Mary and Lazarus) was famous for having given Jesus lodging at her house, and for that reason she was chosen in the Middle Ages to be patron of innkeepers, and Güell wanted to make this an hospitable spot. According to the legend, after Jesus' death, certain Jews put Martha and her brothers and sisters in a ship, and abandoned them to the mercy

NÎMES COAT-OF-ARMS

of wind and waves. But the ship bore them safely to the shores of Provence, where Martha was beset by a ferocious dragon. The saint subdued the beast and having tethered him with her girdle, led him to Tarascón. This too, suited Güell, since he had studied in Nîmes as a young man, where the city's coat of arms depicts a crocodile tethered to a palm tree[2] *. What is more, he was fascinated by the Provence of the medieval troubadours who sung of love, a time and place which the poets and artists of the Catalan Renaixença regarded as the cradle of their Catalan lyricism.

* The small numbers ([2]) refer to the bibliography at the back of the book

ENTRANCE PAVILIONS TO PARK GÜELL,
BETWEEN 1904 AND 1907

A park is an area of enclosed land intended for plants or game, adjoining a city or country house. And this is what Park Güell is: constructed between 1900 and 1914, with its great house to one side and with its architecture and sculpture in the centre of mountainous enclosed land. But, on the other hand, it was intended to be a housing development as well as a park, and thus defies easy definition.

However, one thing we do know is that, as Gaudí himself said, the inspiration for the park came from certain English educational establishments which had the students' dwellings dotted here and there in a private, enclosed park, where each could live as they wished, while respecting certain norms that would safeguard their living in common and isolated[12]. Although no one ever understood Gaudí's words in that way, they are clear and to the point and should be taken literally: an autonomous colony of scholars wishing to live as a community and yet isolated one from another. Based on these premises, Güell and Gaudí designed a park-cum-colony, which was as independent as possible. This conception of the park, as explained by Gaudí[4] himself to a group of architects, provides the guidelines for the book which the reader has in his hands.

Güell had to acquire adjoining land to ensure that the whole formed a 7-sided figure, with seven gates like the Thebes of old, covering a total area of 15 hectares. He then set about dividing it into 60 equal triangular plots [12] (note the numbers, which are symbolic values recurring throughout the park). A house with a garden was to be built in the centre of each single or double plot, making a total of around forty houses for approximately four hundred people, at a time when well-to-do families had a large number of children and domestics. In addition to Can Muntaner – which became the Güell residence in the park, without the Güell family completely relinquishing the Gaudí-built mansion down by the Rambla – only two houses were completed, Gaudí's own house and that of the lawyer Trías, on a double plot in both cases.

Another basic characteristic of the park is that one of the sources of inspiration on which it was modelled was the Sanctuary of Apollo at Delphi [12/17], the archetype par excellence of the great sacred shrines of antiquity

Güell and Gaudí wished to keep the park as inaccessible as an island. The neighbourhood in which the park was situated (la Salud) came into being in 1864 built around a sanctuary, and soon became an upper class residential area, so that for example during the plague year of 1870 it was protected like a fortress with a cordon sanitaire. And here dwelt such personalities as Salvador Samà, Marquis de Marianao and Dr. Sanllehí – both were mayors of Barcelona at the beginning of the 20th century – and Eusebi Güell, who bought Can Muntaner from Samà. The writer Carles Soldevila recalled that this was a happy Arcadia with its back to the big city, beyond the reach of public transport [29]. Güell and Gaudí continued to keep it beyond the reach of the new electric trams. Years later, Dr. Trías, the

PARC SAMÀ, CAMBRILS

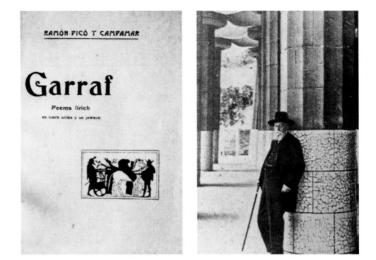

RAMÓN·PICÓ Y CAMPAMAR

Garraf

Poema lírich

en cinch actes y un prólech

COVER FOR THE EPIC POEM «GARRAF»,
BY RAMON PICÓ I CAMPANAR

EUSEBI GÜELL IN HIS PARK

son of the lawyer, wrote with more than a touch of black humour about the tramcar accident in which Gaudí met his end: "The tram took its vengeance on him for not letting it come near the Park Güell".

In the same year of 1899, Dr. Salvador Andreu, an exact contemporary of Güell's and with interests in common, who had become famous because of his patent cough lozenges, formed a group and acquired the large Tibidabo estate overlooking the city, to create a residential area of upper class villas with gardens. This turned out to be one of the most spectacular business deals in the history of Barcelona: five hundred pesetas worth of land become three hundred thousand pesetas over the next fifteen years. But Dr. Andreu had taken the precaution of installing a tram line and a funicular railway providing good connections with the city's transport system. His residential area covered five hundred hectares compared to the Park Güell's mere fifteen. Of course, Güell was much richer. But Andreu had an impressive gift for making money while Güell dreamed up ways of spending it.

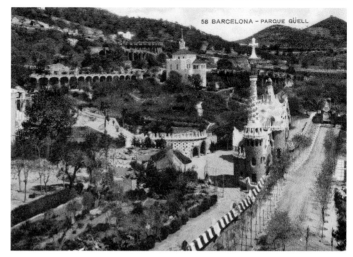

POSTCARD OF PARK GÜELL IN 1908

At all events, in 1892 the Güell mansion had been the setting for the first reading of the lyric poem Garraf [7] – in the presence of the papal nuncio, and a few years later, in the presence of the Pricesses Mª Paz and Mª Pilar, the music by García Robles and the words by Picó i Campanar, Güell's poet-administrator. The author in the wings was Eusebi Güell himself, since the subject, the place, the characters and the symbols were all of his making. It is based on the mega-project devised by Güell and his engineers to bring drinking water from a sea cave in the Garraf massif to a thirsty Barcelona [17], a feat paralleled by that of Faust, in Goethe's poem, building dikes to defend his city against the sea. Both Güell and Faust were builders and engineers, by profession, with the same philanthropic aims and the same message. Man has to outgrow the biblical concept of work as a punishment to be able to secure, attain and increase, using work as creation and liberation, the realisation of beauty, goodness, justice and order in the world.

Goethe, too, was a mason. Given his enlightened ideas, and the fact that work is a basic concept in masonry, it might seem surprising but it is certainly not strange that the poem *Garraf* should

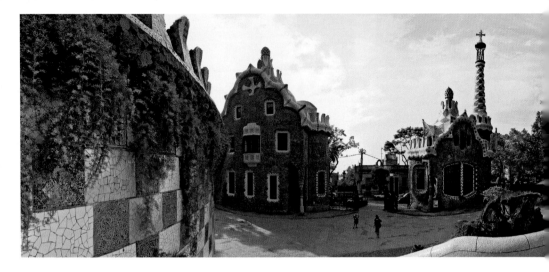

constantly make use of masonic symbolism and terminology. The latter include the mallet representing work, valley, as the term for lodge, the half-bared chest in an initiation ceremony, and the ordeals and symbolic journeys[25] – as in Mozart's *Magic Flute*, not to mention an underlying humanism of a radical kind[23]. At the same time the symbolism is also Christian, Catholic, with concepts like eternal punishment, the Fall, Christ and the Lord's prayer. However, thanks to Güell, Picó i Campanar and of course Gaudí, such different, diametrically opposed alternatives as Freemasonry and Catholicism were able to coexist in the same poem, thanks to their many elements in common, even though, in the world at large, these ideologies were embroiled in a merciless war with both sides condemning the other at the highest levels. In theory, if not in fact, the masons also admitted Catholics into their ranks, but the Catholic church would not accept this under any circumstances. The question of whether there were catholic masons or vice versa was never even raised. Bishop Torras i Bages, the most intellectual churchman of the time, complained that there were *Catalanistes* (champions of Catalan culture) who were masons; but he said nothing

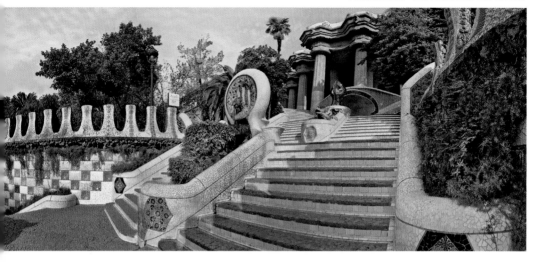

of Catholics who were masons, implying this was unnecessary. On the other hand, in the poem, as in the park (which was its realisation in architectural form) both doctrines appear to form a single philosophical religion, surely because these three men and a certain number of others, saw that they were united in a common theological and ethical root that was worthwhile reviving. And this is what is so strange and unexpected. In this key aspect (although not, for example, on the subject of economic and social equality) these men were absolutely original in their tolerance.

The real hero of the *Garraf* poem is work, as we have said, because as the Latin maxim has it "Labor omnia vincit" (work overcomes all). The latter, personified as the angel Labor, the very synthesis of those contradictions between Catholicism and masonry, hovers above all the characters as they tirelessly address themselves to their work for the good of humanity.

The rampant eclecticism of the poem is patently obvious. But it was so unthinkable that anyone in the Spain of that time should even dream of staging a Catholic-masonic recital for the papal nuncio and the princesses, that if anyone noticed they preferred not to believe it.

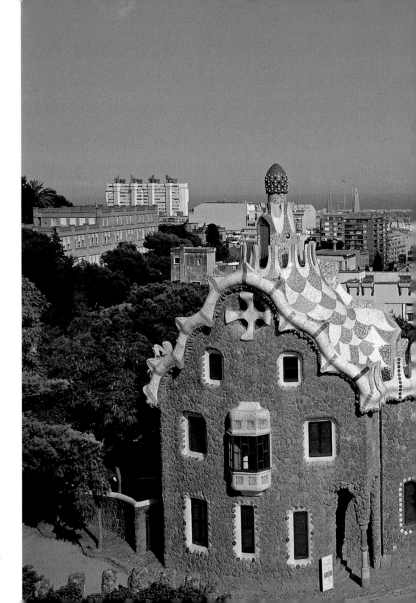

MAIN ENTRANCE PAVILIONS
IN CARRER OLOT

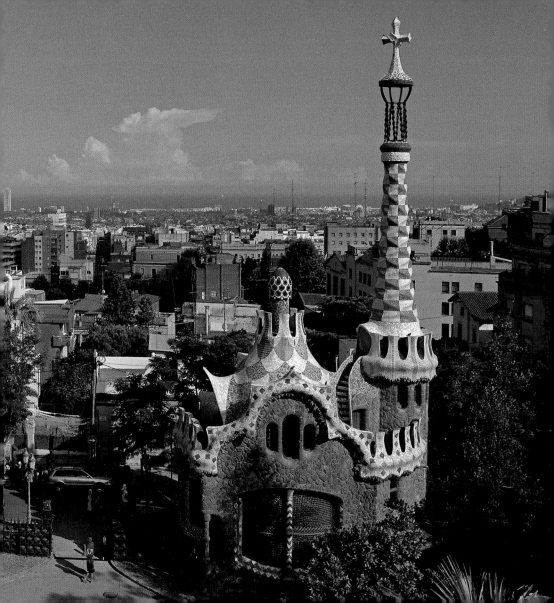

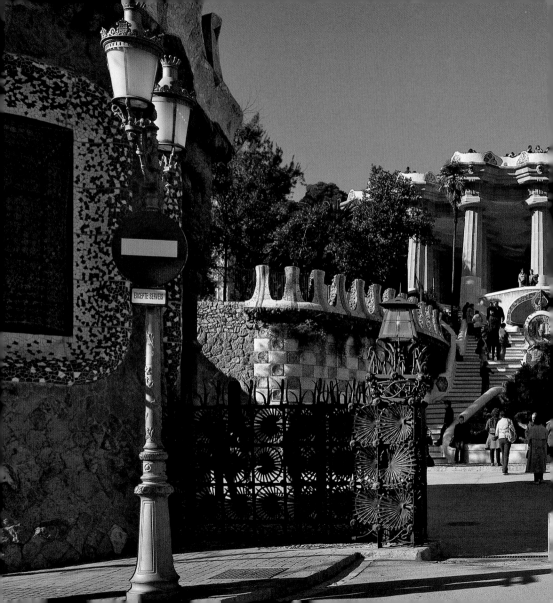

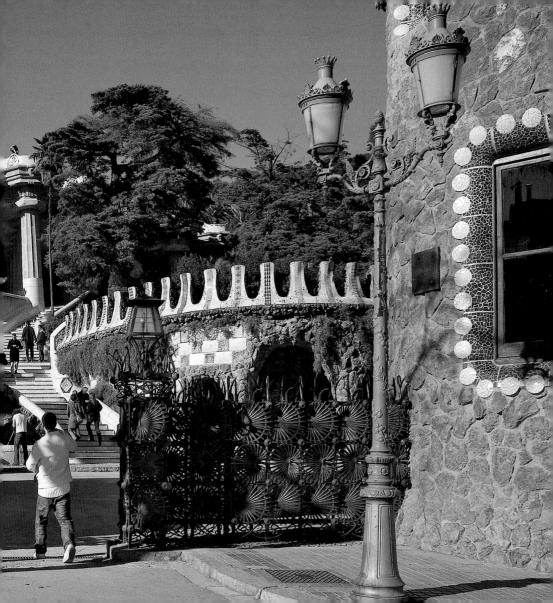

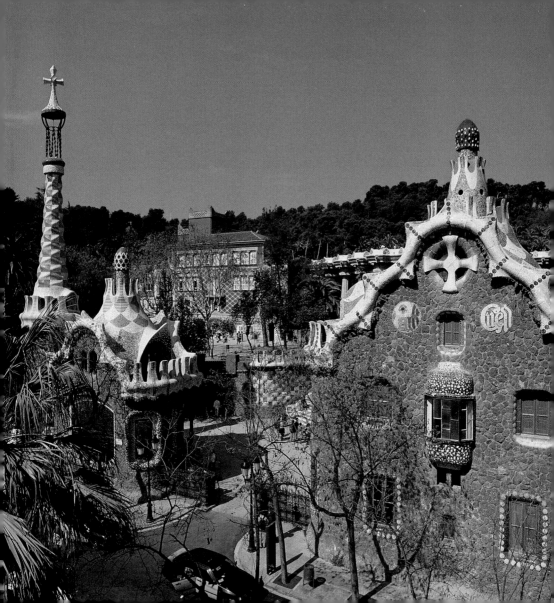

THE SQUARE WITH ELEPHANTS

It is not usual for a residential housing development to be walled. But the fact is that in this park nothing is usual or normal. For a start there is Gaudí's great architectural contribution, but there is also its bid to be a utopia or initial essay in the design of a perfect, if limited, society.

In the Carrer Olot stands the main gateway to the Park Güell. But before passing through, it is worthwhile taking note of the words ALABA / POR ("praise for") inscribed on the walls just to one's left. Given Gaudi's love of the ciphered message, we might well suspect this to be an anagram: LABOR PAA contains the same letters, and a masonic manual dating from 1871 [25], written in Spanish, explains that P\A\A\ means *casa de hospedaje*, that is "hostelry" or "lodge", the latter of course being the English

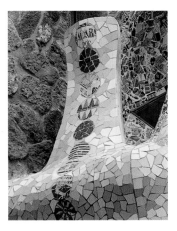

MERLON OF A PAVILION

term for Spanish *logia*, the workshop or temple where the masonic brethren gather to carry out their labours. And thus, the Park – thanks to Saint Martha and the poem *Garraf* – was to be the rooming House of Work.

The walls of the park are decorated with white and red friezes, the colours of the ancient Phoenician navy [2], indicating in this way that the park is an island or ship, like Thomas More's famous island of Utopia, reached only by sea. The 14 medallions set on the wall, with the words "Park" and "Güell", suggest that this is a park in the English style; on the other hand, the five-pointed star in the P of the word Park is inverted like a horned devil suggesting the esoteric nature of the place, and the axe

ENTRANCE IN THE CARRER OLOT, THE TWO PAVILIONS WITH THE FORMER GÜELL HOUSE IN THE BACKGROUND

DRAWING BY JOAN MATAMALA OF THE PORTAL THAT WAS NEVER MADE

THE CURRENT GRILLE OF THE ENTRANCE, WHICH COMES FROM THE CASA VICENS

PLAN SHOWING THE PAVILIONS LIKE OPPOSING SNAKES' HEADS

alongside it symbolised Work, Labour. By having acacia trees planted in this street, before the entrance, Gaudí was making reference to the famous secret brotherhood.

Park Güell is, then, brimming with symbolism. Of the 7 gateways intended for the Park, only 3 were ever built, with strong grilles, two at either end of the ornamental wall, and one at the top end of the enclosure; but the one intended for the main entrance, the largest and most spectacular of them all, in keeping with the wall, was never actually built. Furthermore, Gaudí planned to put an iron deer next to the gate, which would disappear as if by magic when the mechanism was activated by someone touching the railings [18]. This was a reminder of Solomon's *Song of Songs*, where the woman says : "My beloved is like a roe. Behold, he standeth behind our wall, he looketh forth in secret!". The splendid railing that is there now was taken from the Casa Vicens, Gaudí's first great work.

On either side of the entrance are pavilions of a most curious sort, since the outer wall encloses them both – a feature which can be seen more clearly from the plan – forming

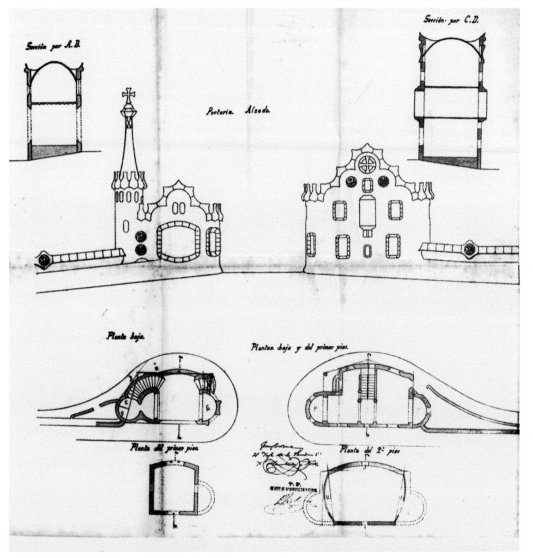

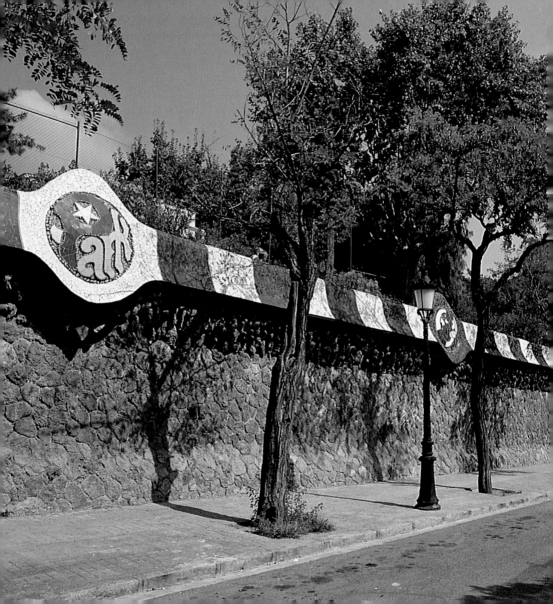

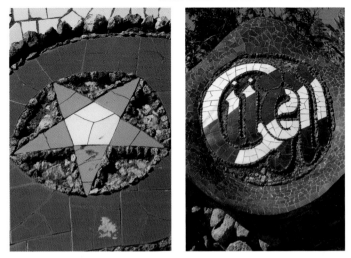

RED AND WHITE BARS HAVE BEEN, SINCE
ANTIQUITY, THE COLOURS OF THE NAVY:
THE PARK IS A SHIP AS MUCH AS AN ISLAND

FIVE-POINTED STAR INSCRIBED IN THE
WORD PARK

MEDALLION IN THE FORM OF CIGAR BANDS

two facing snakes[21]. This is probably a reference to the pair of snakes borne by Mercury on his staff, indicating that aggressive forces mutually neutralise one another, and for that reason a symbol of protection of peace and health. This hermetic symbolism (literally relating to Hermes) is found elsewhere in the park. In this connection it must be remembered that Gaudí mixed several types of symbolism in one[2], a fact which should remind us to be as cautious as we are flexible in our interpretation. This period spanning the end of the 19th and the beginning of the 20th century saw an extraordinary flowering of esoteric doctrines and practices as a spiritual response to positivist science, and both Güell and Gaudí were true sons of their times.

It has been rightly said that the place evokes personal memories from Eusebi Güell's youth[6], but it might be more accurate to speak of memories from his earliest infancy. Hence the games and pastimes that are represented[1]. For example, opposite the pavilion on the right (in this book right and left will be from the perspective of the entrance in the Carrer Olot) there is a strange

grotto. It was intended to be a shelter for carriages, but at the same time, judging by its size and markings, it resembles nothing more than an elephant. Only its belly and its feet are visible, although a careful search of the interior and exterior will reveal the trunk and tail, and further diligent searching will even reveal the pachyderm's heavy legs. There are old people in the area who still call it "the elephant", and it is probably a reference to a childhood memory of Güell's (and Gaudí's), when India came under British rule in the mid-19th century, and its exotic appeal became famous throughout Europe. Güell was born in Barcelona in 1846, and as a child he used to admire the attractive magazine illustrations showing opulent maharajas on their placid mounts. Gaudí too must have been amused to have the ancient elephant protect such modern contraptions as the motor car. For good measure, he was also paying tribute to the famous medieval crypt of Sant Pere de Rodes (near Cadaqués), which has a central column very similar to what we see here[2], like the tree of life, and it similarly has a hole revealing the hollow interior. For Gaudí, the hole signifies that what seems solid had nothing within; that all is art, illusion. And on that basis, from then on, the visitor to the Park knows what to expect.

As can be seen, a sense of fun prevails. And this is not the only elephant either. The two pavilions on either side of the entrance, for example – which owe very little to architectural tradition and almost everything to Gaudí's genius (just as he was entering his great period)[1]. They have solid rustic walls, like those of the cave, while the roofs amaze with their attractive pastel colours which "in gentle sunlight produce reflections and iridescence which are sometimes dazzling"[12], an example of Gaudí's exquisite sensitivity. They are saddle-shaped, an emblematic feature in his architecture. But in this case not horse saddles, but rather elephants' howdahs, obviously much wider and able to carry towers on top of them as seen here – the sort shown in ancient paintings thronged with warriors. The latter were, after all, used as defence towers with crenelations, when the elephant was used to terrify the enemy in battle.

CAVE FOR SHELTERING CARRIAGES THAT
LOOKS LIKE THE TRUNK AND TOUR LEGS
OF AN ELEPHANT

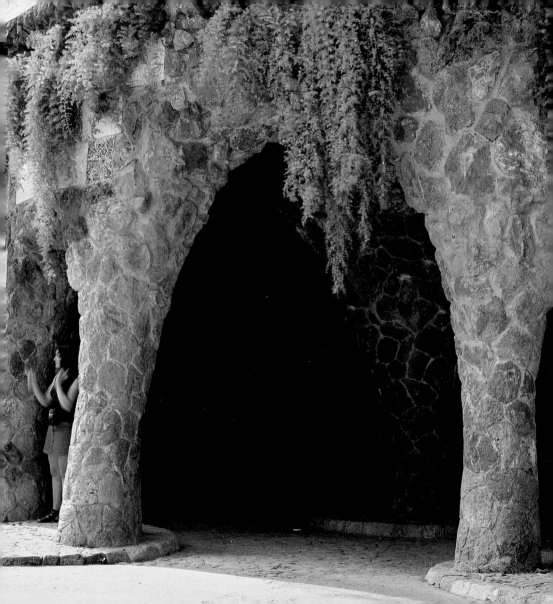

INSIDE OF THE CARRIAGE
SHELTER WITH THE COLUMN
IN THE FORM OF A GLASS,
INSPIRED BY THAT OF SANT
PERE DE RODES, ACCORDING
TO E. ROJO

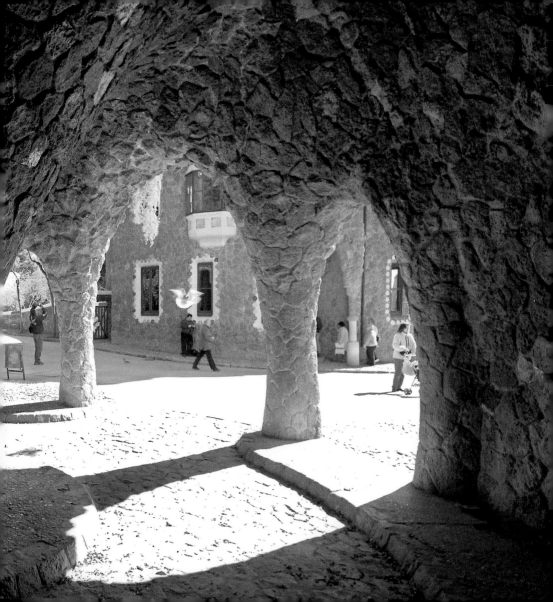

Apparently the head itself is not visible, but the game continues, and inside the pavilion on the left (where the bookstore is now), the ceiling looks like an enormous ribbed palate, as found in an elephant's mouth, and the large windows look like two great ears. Next to it on the roof, the tower takes the form of a great erect trunk and, as if on a jet of water – although actually of fine iron – it sustains a cross aloft, just like the typical *ou com balla* (dancing egg) seen at the Barcelona Corpus Christi celebrations. The trunk on the other hand seems to be made of twisted palm leaves, like the palms carried by young girls on Palm Sunday. In Gaudí's case, the idea of the elephant goes back to his childhood years, when he used to go to Montserrat with the poet Verdaguer. We know that they visited the Coves del Salnitre in Collbató, where there is an elephant-shaped rock, which Verdaguer refers to in the *Llegenda de Montserrat*: "... the elephant that carries a tower on his back". In the entrance hall in the La Pedrera building on the Passeig de Gràcia, Gaudí again summoned an elephant from his imagination, with its famous "foot", carrying the first floor gallery on its back.

Everything indicates that Gaudí conceived the whole of the square at the entrance as a giant puzzle, like a popular children's wonderland [1] for young and old, a puzzle whose pieces, with their diverse creative origin, needed to be deciphered and assembled. It is likely that Gaudí was familiar with the old esoteric fable, as simple as it is wise. Four blind men wish to know what an elephant is like. The first feels the foot and declares: an elephant is like a rugged tree trunk. The second touches the belly and explains: it's a ceiling made of warm rock. The third strokes the trunk and exclaims: it's like a snake. And the fourth runs his hands over the ears and says: an elephant is like a great fan, wafting air.

Exquisitely faithful restoration has reclaimed these small but priceless pavilions, returning them to their original form and distribution. In his construction, Gaudí [30] used simple, ordinary paints and materials, and combined traditional building techniques with the prefabricated materials, thanks to Güell's cement

TOWER OF THE VISITORS' PAVILION THAT SUPPORTS THE CROSS SET IN SIX DIRECTIONS

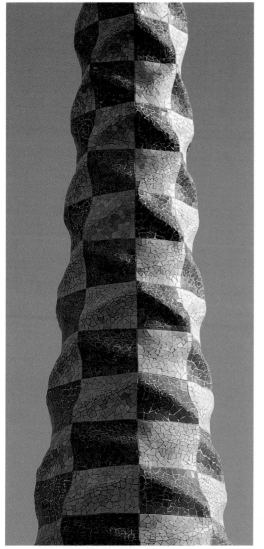

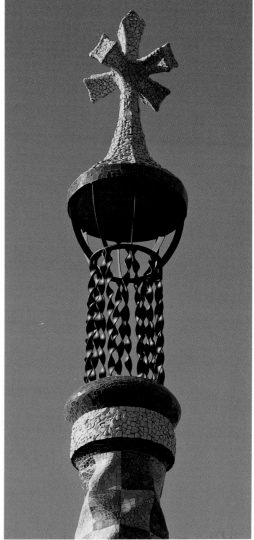

business. The *trencadís*, the popular technique using broken ceramic pieces, raised to the level of great art by Gaudí, provides perfectly flexible decoration for the roofs – arranged as scales, as if they were fabrics, furs and metals evoking an oriental dream world. The scales, depending how you looked at them, are axe-shaped – like those next to the P on the medallions, the universal symbol for work.

The pavilion on the right was the old concierge, occupied at one time by an old Güell tenant and his sister. It has a living room and kitchen downstairs; bedrooms and privy on the first floor; and an attic with a fireplace and mushroom-shaped chimney. The (smaller) pavilion on the left, with chairs and a telephone for visitors, is oval in plan, walls without arris and parabolic arches, with two semi-circular spaces covered by an overarching ceiling – the one in the form of a palate – and above that an egg-shaped cupola (with a stove on the floor, which is no longer extant) and a flue leading to the chimney, forming an almost identical mushroom to the neighbouring one. The entrance to the two pavilions is in the angle, through a small porch, of the sort frequently met with in buildings by Gaudí and Domènech i Montaner. This feature is no doubt inspired by the chamfered street corners in the *Eixample*[19], the well-to-do area in the centre of Barcelona. The restoration of the details has been just as painstaking: the sunken cruciform windows, the strangely crafted grills, the panes with their little mills, the original banisters, the long armed cross, etc.

The white and blue rectangles of the tower for their part (fashionable colours at the time) seem to be based firstly on the banner of the Comillas family – the Marquis of that name was Eusebi Güell's father-in-law – and secondly on the family coat-of-arms of the Counts of Montcada before they took part in the conquest of Mallorca by Jaume I. Tradition has them related to the Bavarian crown, with its blue and white heraldic crest[2]. This allowed Güell to link his name with the very Count-Kings of Aragón and Catalunya. It is evident that he aspired to the title of count with his lordly airs and his sumptuous receptions in the Palau Güell and the

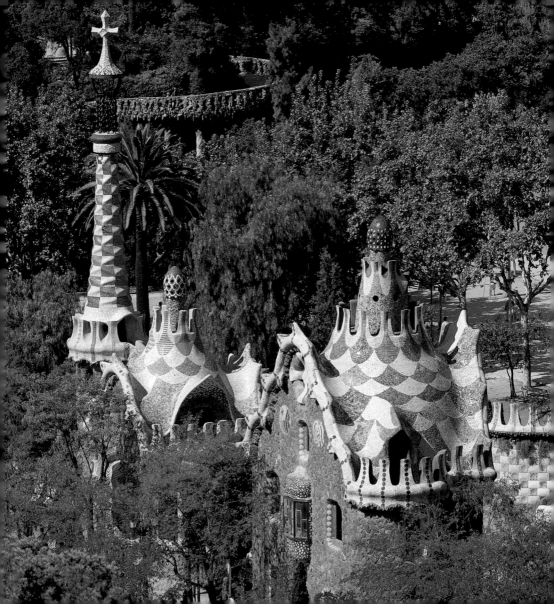

Park Güell. Bavaria, moreover, was Wagner country, and Wagner was the musical darling of the Modernists, so that Güell felt very much at home as a European aristocrat in Europe. King Alfonso XIII made him a Count in 1908 [17], and, in gratitude, after his death in 1918, the family donated the summer house and gardens to the crown of Spain, which became the royal palace of Pedralbes.

Lastly, the restoration of the pavilions returned the colours and details of the mushrooms that crowned them to their original state. They represent two young examples of the genus *amanita muscaria*, with red cap and white spots (spotted fly agaric), known popularly in Spanish as *matamoscas* (or fly killer) and in Catalan as *reig bord* and *reig foll* (false or mad fly agaric). Gaudí became interested in fungi thanks to Mr. Calvet, an amateur mycologist, and used them for the first time as an architectural motif, in the gallery of the Calvet's house, which he decorated with various examples. Subsequently, he imitated them in his own house in the Park Güell, in the vestibules and chimneys in the La Pedrera, and so forth. The attraction of these fungi resides not only in their varied, country flavour as an item of cuisine, but in their fascinating shapes. Toadstools of the genus *amanita muscaria* are known to be hallucinogens and to act rather like the *soma* of the Greeks, the Mexican peyote mushrooms or other elixirs and dainties used in ancestral religious and secular ceremonies, inducing trance, euphoric and soporific states and "trips". Which is why they are represented together with shamans, druids, wizards, witches and gnomes, and provided a source of inspiration for many artists and intellectuals of the 19th century, such as Baudelaire, Delacroix, Nerval, Verlaine, Rimbaud, Hugo, Balzac, Nietzsche, Yeats, O'Neill, etc. All this explains why Gaudí treated the amanites in such an ambiguous way, making them gleamingly attractive and spectacular despite being mere outlets for smoke.

TOWER OF THE PORTER'S LODGE CROWNED BY AN AMANITA MUSCARIA

CARICATURE OF GÜELL PICKING MUSHROOMS (PICAROL, 1911)

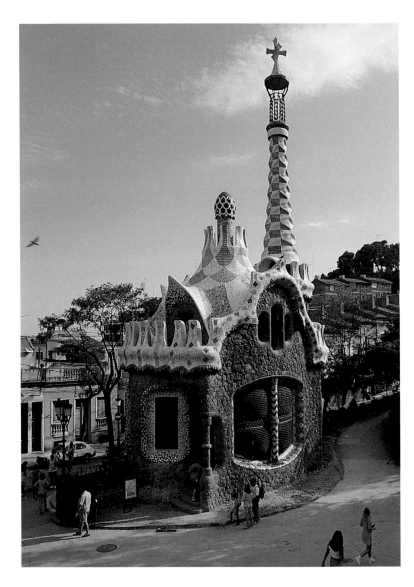

VISITORS' PAVILION,
CURRENTLY THE BOOKSHOP

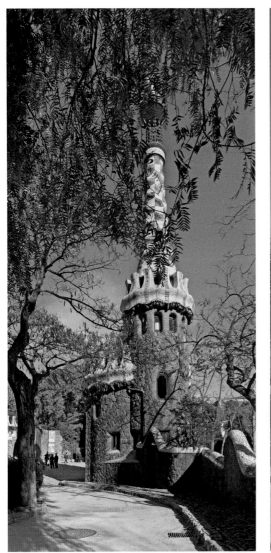

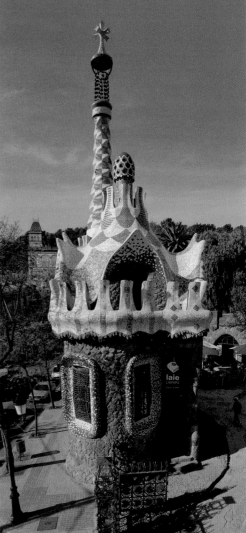

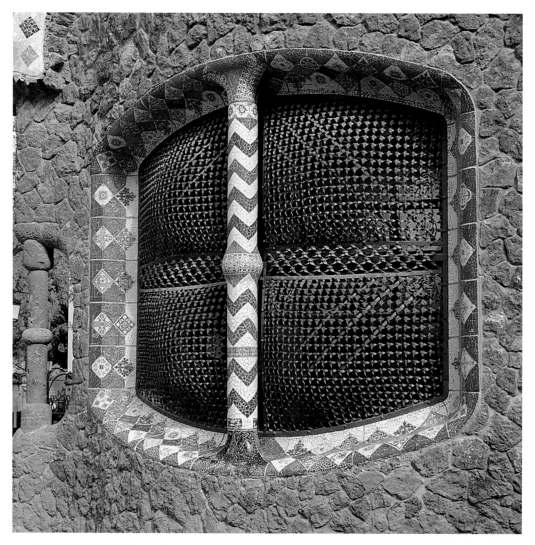

LARGE WINDOW OF THE VISITORS' PAVILION

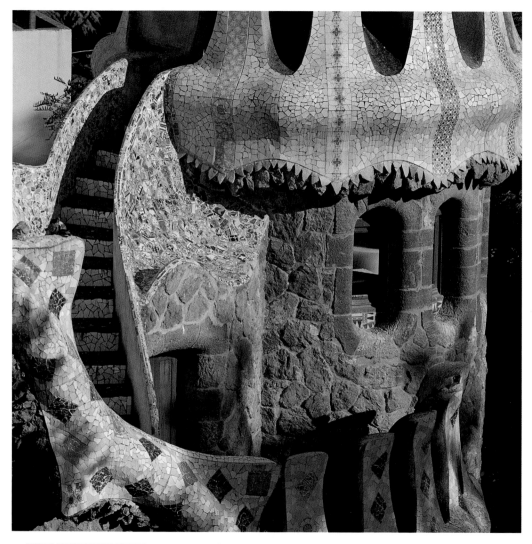

DETAILS OF THE VISITORS' PAVILION

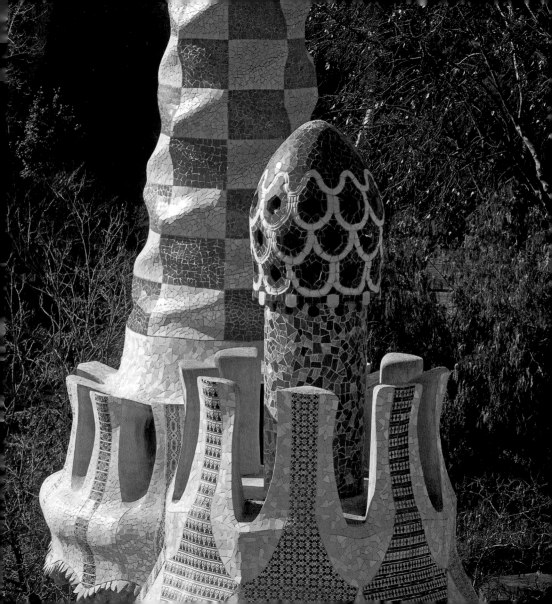

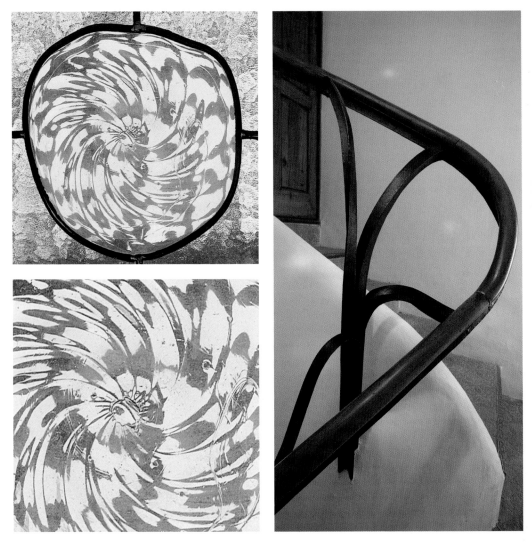

STAINED GLASS WINDOW, HANDRAIL AND GROUND FLOOR OF THE VISITORS' PAVILION WITH THE FLUTED VAULTING THAT SUGGESTS A PALATE

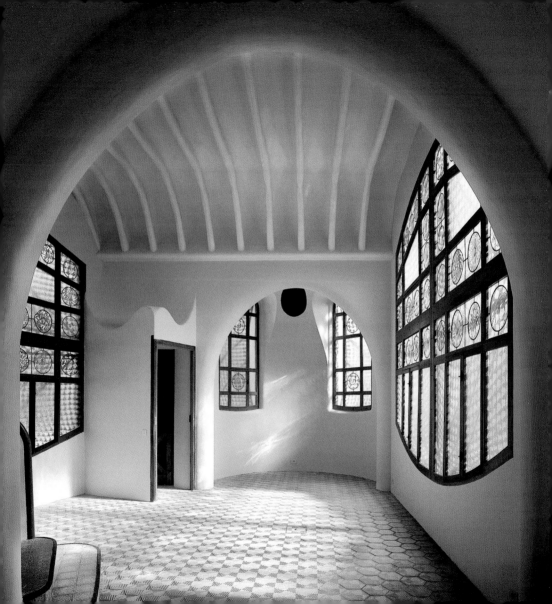

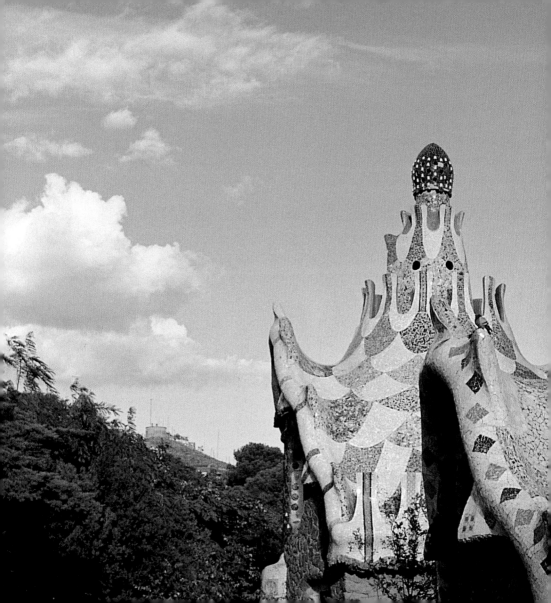

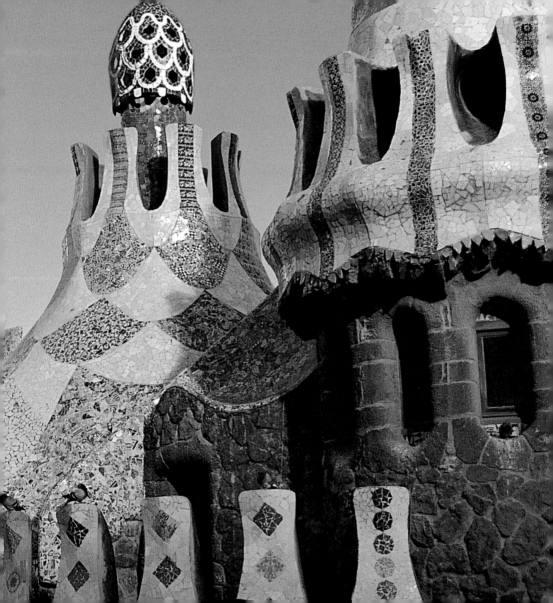

THE OLD PORTER'S LODGE,
CURRENTLY THE INFORMATION
CENTRE OF PARK GÜELL

ROOF WITH CRENELATED
TRIPLE TOWER THAT LOOKS
LIKE AN ELEPHANT SEAT

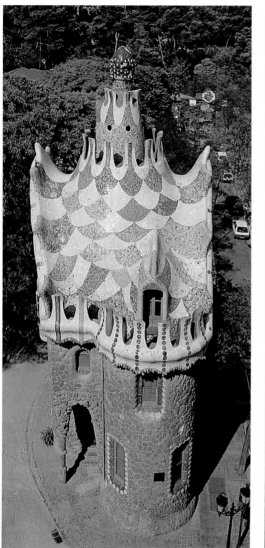

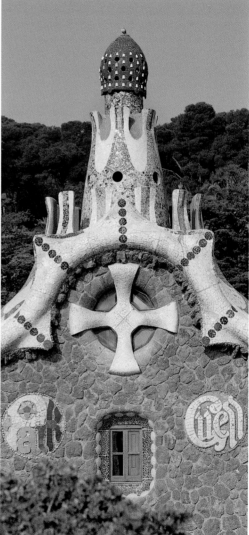

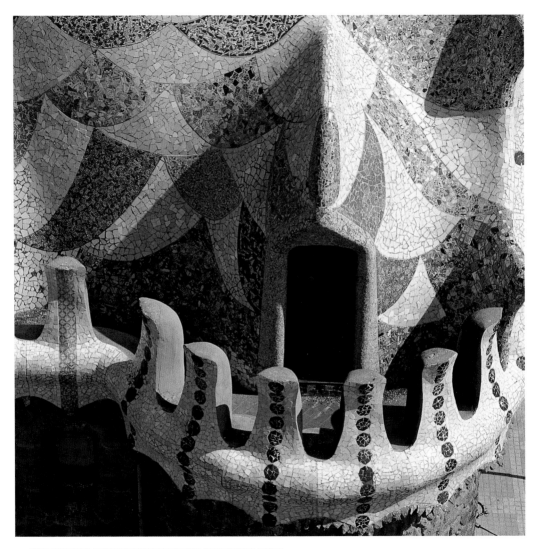

IN THE TRENCADIS OF THE ROOFS THERE ARE AXES WHICH BECOME KNIVES

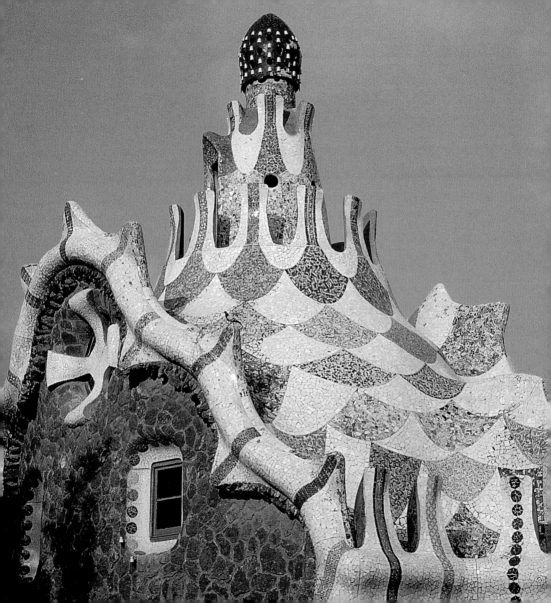

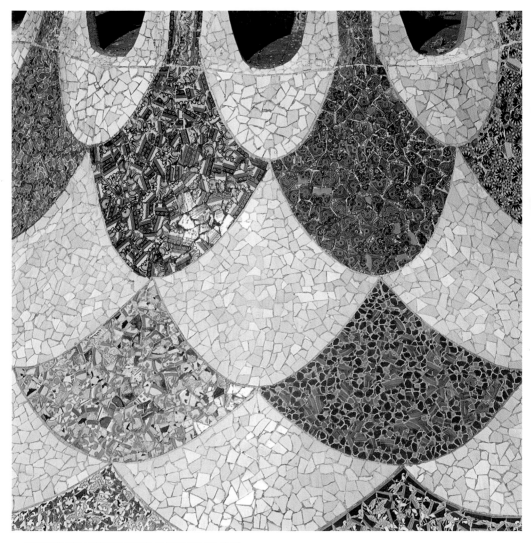

MOSAIC OF AXES, UNIVERSAL SYMBOL OF STRUGGLE AND WORK

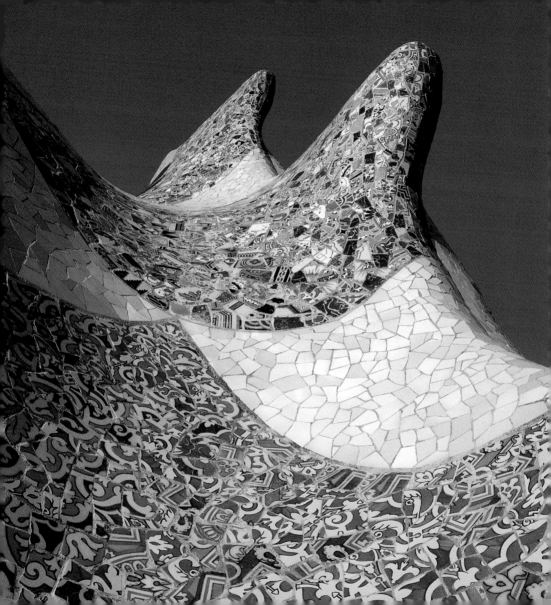

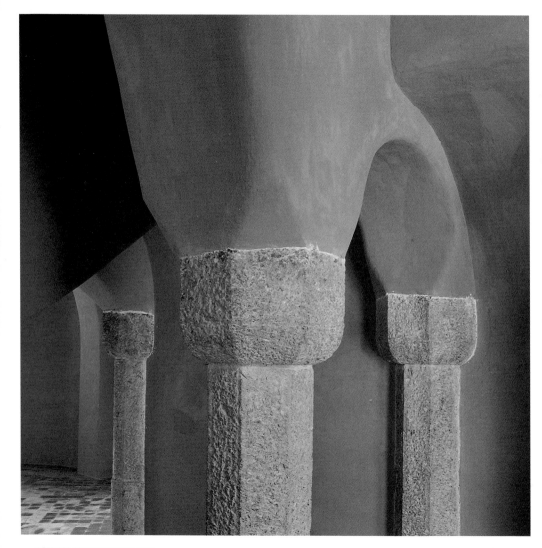

INTERIORS OF THE PORTER'S LODGE

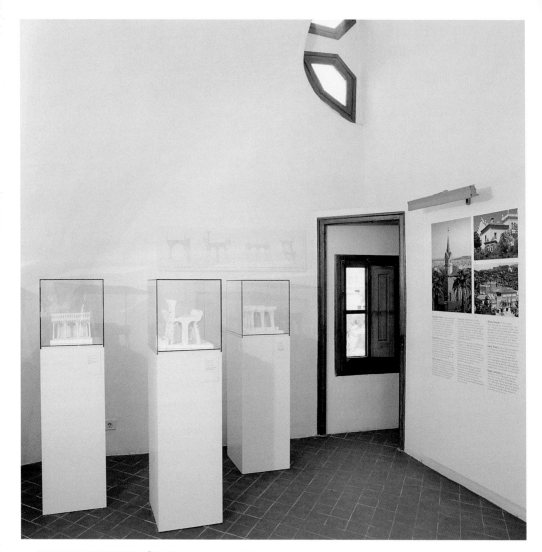

INFORMATION CENTRE OF PARK GÜELL. EXHIBITION OF MODELS OF DIFFERENT ARCHITECTURAL STRUCTURES OF THE PARK

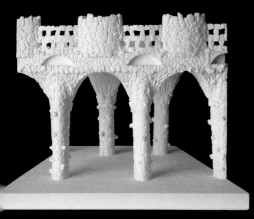
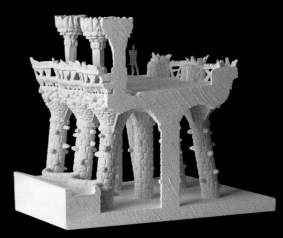
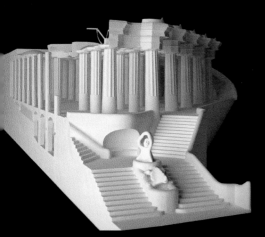
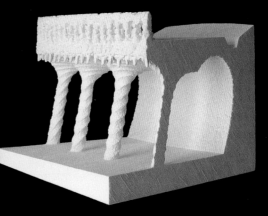

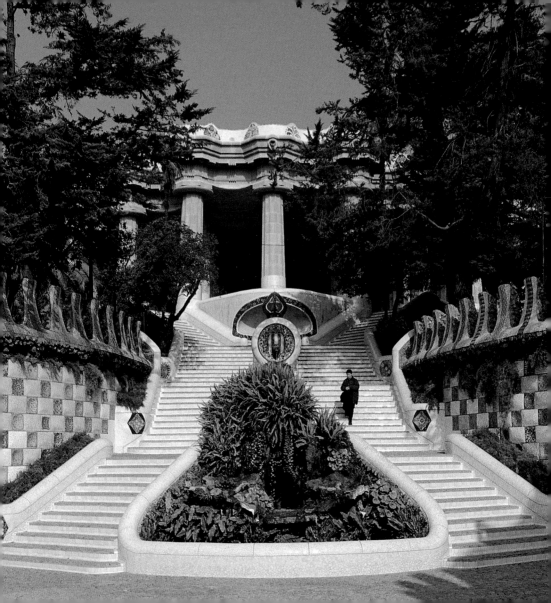

THE WARLOCKS ON THE STEPS

Eusebi Güell, the son of a manufacturer and politician, studied in Nîmes in the south of France, where he read social sciences, politics and physics. Married to Isabel López, the daughter of the Marqués de Comillas, one of the most powerful men in Spain, he became extraordinarily rich, thanks to industry and finances. He lived a very intense life involved with the Spanish monarchy, conservative politics, the nascent Catalanist movement, and the patronage of cultural initiatives. He himself was a painter, linguist and, let it be noted, an architect and medical theorist. He aspired, then, to encyclopedic knowledge, and travelled widely throughout Europe, including Russia, the Holy Land and North Africa.

He enjoyed great prestige for his generosity, tact and moderation, although when the riots of the *Setmana Tràgica* (Tragic Week) broke out in 1909, this reputation did not stop angry revolutionaries from wanting to attack his mansion and the Comillas home for their fervent defence of the Vatican.

On the 26th October 1904, Güell and Gaudí presented their plans for a park to the City Council, and applied for building permission. The choice of day to do this is rather strange, amusing even, dedicated as it is to Saint Lucian and Saint Marcian, who had been magicians. It was as if Güell and Gaudí aspired to be magicians themselves. What is more, the medieval legend of these two patron saints of Vic had been turned into a poem by their friend Jacint Verdaguer, when he was 18 years old – a notable religious epic poem. Here is the plot: to put an end to Christianity, the Praetor of the town orders his henchmen to corrupt the population, and tells Lucian and Marcian, who are very young and given

FRONT VIEW OF THE STEPS, WITH VARIED
AND SYMMETRICAL SHAPES

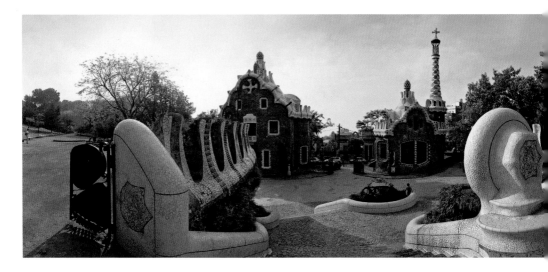

to astrology and black magic, to rob the maidens of Vic of their innocence. Vices are rife everywhere, and one after another the hapless maidens succumb to the attractions of the handsome and insatiable lads. Only one virgin escapes their snares, the charming and vivacious Aurelia, who is under the protection of the Virgin Mary, as they are of Venus. And when one night they fly into her room and find her asleep, the radiance of the cross on her breast hurls them to the floor, and they realise there is a power greater than their own. They are converted to Christianity and with the enthusiastic help of the young woman, preach the faith of Christ, but the Praetor has them summarily burned at the stake, and rejects Aurelia as a madwoman.

This story captures to perfection the essential symbolism in the life of Güell and Gaudí, and manifest in the Park, in the art, structures and statues etc. which have not only a Catholic and masonic meaning, but an alchemic significance. Alchemy is suggested as soon as the entrance is reached, since what seem to be elephants from the outside are the Alchemist's House on the inside (the pavilion on the right) and an oven with its egg-shaped dome and chimney (the pavil-

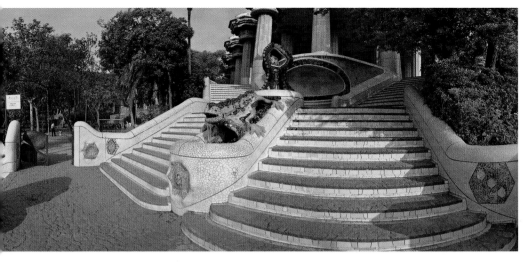

ion on the left). And above all, good smoke and bad issues through the mushroom-shaped chimneys. In all these things, then, there are positive aspects, relating to white magic and negative aspects, relating to black magic, in keeping with the honest spirit of the Catholicism and freemasonry of the early 20th century.

The staircase, flanked by crenelated walls, has a central group of basins or pools with cascading water. In the first of these there are stone tablets and strange figures including, on the left, a compass and protractor and, on the right, a thick circle from which two sticks project upwards and three downwards (to see it well it's best viewed from a distance). Here Gaudí and Güell are presented as builders and architects, with the symbolic tools of their trade, which are in fact the same as those utilised by the masons. Mason after all means builder, and the ideal figure characterising masonry is God as the Great Architect describing the circle of the world with his compass. As for the lines that issue from the circle, the 2 and the 3 make 5, which is the most essential number in nature (for example the five fingers of the hands) and in the Park. In the pool itself there are coral forma-

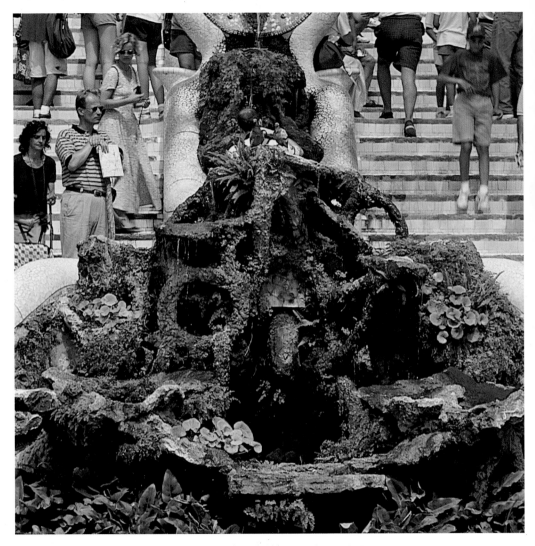

CENTRAL FLOWER BED WITH GRADUATED COMPASS, ON THE RIGHT, AND WORLD CIRCLE, ON THE LEFT

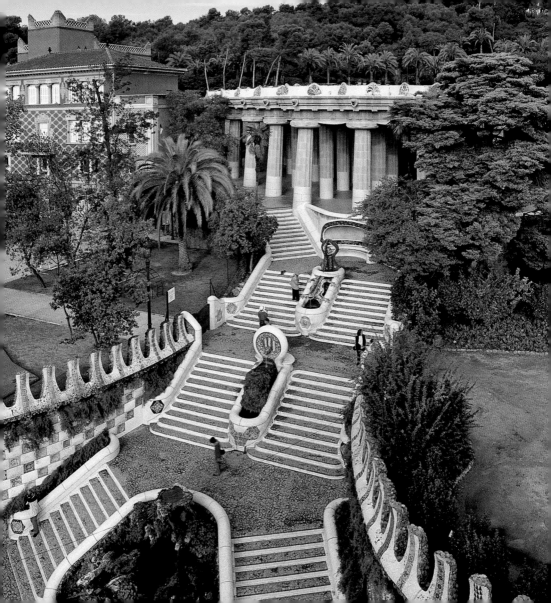

tions. These are symbols of stone in the rough, which the alchemist (and all human beings who seek wisdom) must purify within themselves and, allegorically, in the oven or crucible laboratory.

On the first landing there is a hexagonal stone on the wall inscribed with the legend "Reus 1898" and a champagne glass. Why? Most probably it was only after the summer visit that the Marqués de Marianao paid that year to the Parc de Samà, in Cambrils, that Güell decided to buy the Can Muntaner property from him to create his own Park. And then the three men, with their common roots in the Tarragona area, went to the Hotel Londres in Reus, to celebrate in high style not just the sale of the property, but coincidentally the masonic festival of the summer solstice on that 25th of June. Gaudí was also celebrating his 45th birthday, the age at which he became eligible to receive the rank of Grand Master Architect, according to the ordinances of the followers of Hiram[25]. This detail of the champagne celebration is represented by the twisted colonnades of the Portico adjoining the Güell house, as we shall see.

On the sides of the stairway there are some curious six-sided concave or convex tiles, reminiscent of the hexagonal cells of honeycomb[2]. The latter, marvellous constructions and symbols that they are of work and communal life, not just in the social but above all the spiritual and moral sense, are also specific instances of the park's esoteric ideology.

On the second flight of the steps, the crest of the principality of Catalunya is of particular interest, with the four blood-red bars on the field of gold, giving the Park the seal of Catalanist ideology always in the forefront of the minds of its creators. It is worth while seeing this in its setting on these steps which are so evocative of the Piazza di Spagna in Rome[19], built by De Sanctis in 1723. This, in turn, also suggests that the park is Catalan Spanish, as Güell and Gaudí themselves considered themselves to be, despite Güell's jibes against the "Meseta" (that is, central government). A bronze-coloured snake's head emerges from the centre of the crest, like those that the Hebrew Moses or the Greek Aesclepus lifted with their staffs to defend their peoples from plagues. If it is horned, it is because it appears this way in illustrations of alchemy, and its canine looks are a refer-

THE SNAKE'S HEAD WITH HORNS, COVERED WITH BRONZE-COLOURED GLAZED CERAMICS

FIGURE CONSISTING, BELOW, OF THE TRIPOD USED BY THE PYTHONESS OR SEER OF APOLLO AND, ABOVE, OF THE OMPHALOS - THE WORLD'S NAVEL - OR PHILOSOPHER'S STONE

ence to the hound that, together with the serpent, accompanied Aesclepus, god of medicine. The frieze around the crest is formed of the fruit of the eucalyptus, a tree with a great capacity of absorption of water, an ideal choice for drying out marshy areas and banishing malaria. All this is a reference to Güell as the author of the treatise *Immunity through leucomaines*, on prevention of epidemics[5], the scourges which had taken the lives of a million people in Spain alone over the course of the century as a result of not taking precautions. Much of this mortality had occurred in Barcelona, the most overpopulated city in Europe. The Park and the book were the pride and glory of Güell's later years, indicative of his ardent philanthropy.

On the rim of the third basin one of the most attractive and popular figures created by Gaudí poises its feet: the alchemist's salamander, the animal embodiment of fire, as the stupendous colours on its back demonstrate. Here in this figure, the presence of Nîmes and alchemy is most noticeable, reminding us at it does of the white marble crowning the column erected in 1533 in the Place de la Salamander in Nîmes. This was in honour of King Francis I, who was much given to

alchemy and regarded this beast as his symbol, along with the motto "I feed on it and extinguish it", referring to fire, the element in which it could live and which it could even extinguish, standing for moral strength assumed in the face of adversity[27]. But the Park Güell resounds with other references to Nîmes, such as the crocodile tethered to a palm tree on the coat of arms (here substituted by the salamander with two palm trees planted on either side of the steps) the laurel wreath crown (the laurel garden next to the Güell house). And there are other motifs taken from the Jardins de La Fontaine[2], such as the ruins of the temple of Diana, the pre-masonic inscriptions, the vantage point at the top of the Torre Magna, the amphitheatre and the Roman Temple.

At the top of the fourth flight of the steps there is a brown figure, whose lower part is formed of a tripod (similar to a stool) like that used by the female seer at Delphi – transported by the mixture of smoke of pine vapours and aromatic substances – when giving the oracle's message in more or less intelligible words. It seems, however that here Gaudí was mixing the tripod with the stone *omphalos*, the navel of the world, which was also in the sanctuary of Apollo at Delphi covered by a net, whereas the one in the Park is protected, according to legend, by three snakes. But since this stone disappeared and it is not known what it was like, it might perhaps have represented the philosopher's stone of the alchemists, or both things at the same time, as is often the case with Gaudí.

At all events the path from the entrance to the Park to this point can be very broadly summed up in the following way: architecture and sculpture depict the working of the symbolic alchemist's process which seeks to transform material man into an immortal sage. The pavilion on the right is the Alchemist's, and in Güell's day it housed a brother and sister, like Apollo and Artemis (Diana) the masculine and feminine principles, The other pavilion, with its egg-shaped or embryo-shaped cupola, and the adjoining tower, evokes the alchemist's oven, and through its lofty chimney there emerges not water but purified vapours or perhaps incense. And in the three pools on the steps, coral represents uncut stone, which the uninitiated should purify; the bronze snake in the next one signifies the

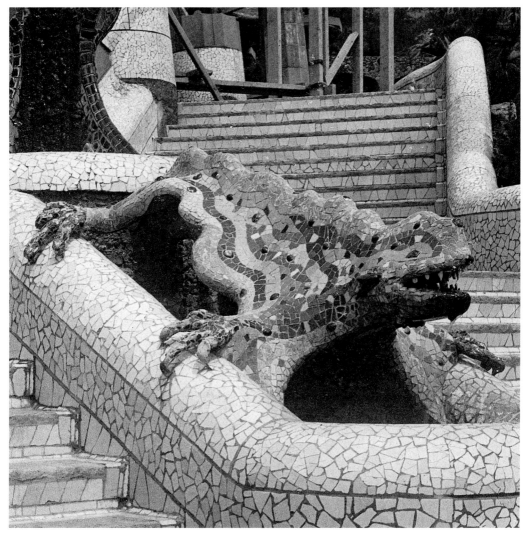

OLD PHOTO WHERE ONE CAN APPRECIATE THE ORIGINAL TEETH AND CLAWS OF THE SALAMANDER

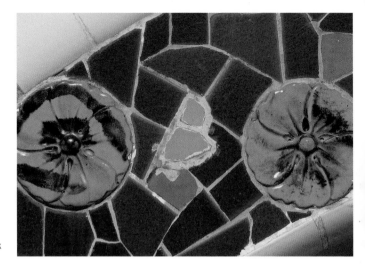

BENCH WHICH IS SHADY IN THE SUMMER
BUT SUNNY IN WINTER, SHAPED LIKE
THE MOUTH OF THE GREEK TRAGEDY MASK

power of the superficial and the fixations of the basic human being, and finally in the highest, the union of the masculine (sulphur) and the feminine (mercury) is enacted by the water in the water-fall and the salamander's fire, represented at the top of the steps by the stone of Gnosis or wisdom.

Having said that, comparison of the Park's structure with that of the sanctuary at Delphi suggests that close to the tripod there would be the place where Apollo killed the serpent Python[12] over the crack in the ground leading to the underworld. In this way, *omphalos* (if that is what it is) or the philosopher's stone (if not) establishes the connection between this world, the gods, and the dead, symbolised by the cistern (crypt) under the colonnade. Beyond the tri-pod there is bench where one can sit and admire the view, so carefully designed by Gaudí that it is in the sun in winter but in the shade for the rest of the year. It resembles an open mouth, and could easily be that of the seer, or the doors of the waters under the earth. It is not easy to understand what it says, but this mouth is tragic: the lower lip is tense with deep sobbing, be it for horror or the redemption of revelation.

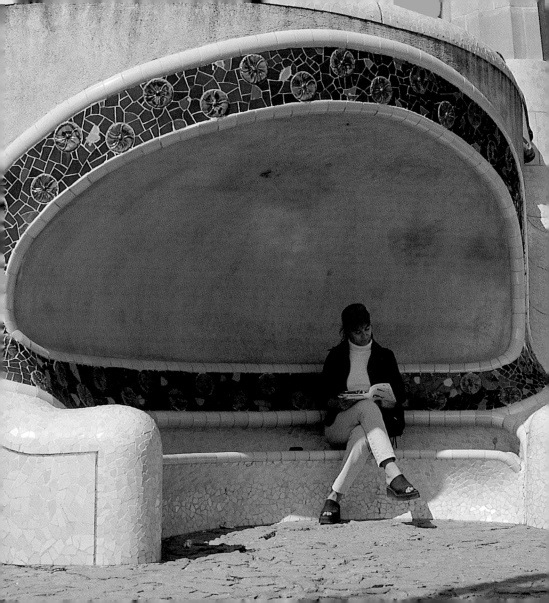

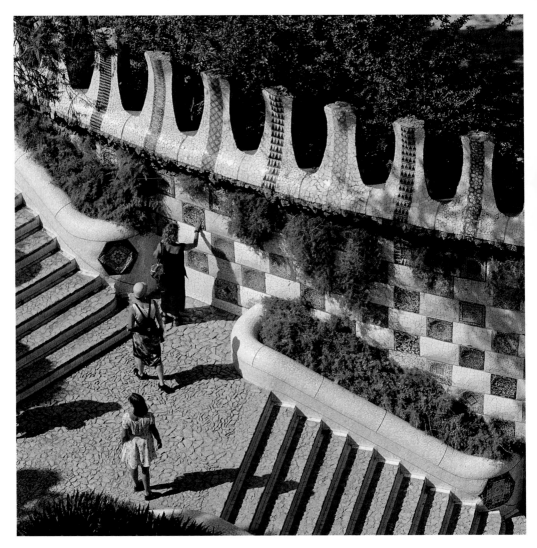

CRENELATED WALLS WITH FLOWER BEDS, AND FIRST FLIGHT OF ELEVEN STEPS

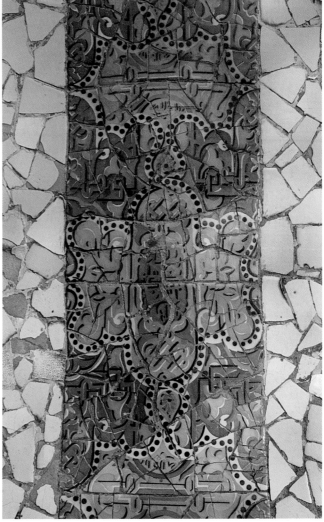

TAKING PLEASURE IN THE ALWAYS GAY AND VARIED ORNAMENTATION. KENT AND PRINDLE EMPHASISE THE FUN ASPECT OF THE PARK

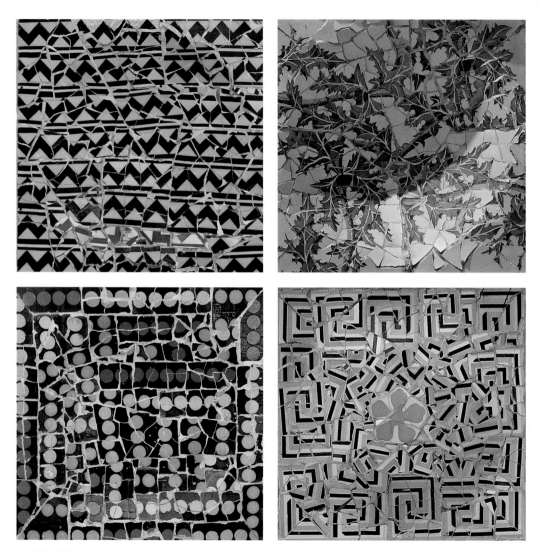

TRENCADÍS MOSAICS PLAYING WITH BOTH CONCAVE AND CONVEX SHAPES AND WITH ADMIRABLE COMBINATIONS OF FORMS AND COLOURS

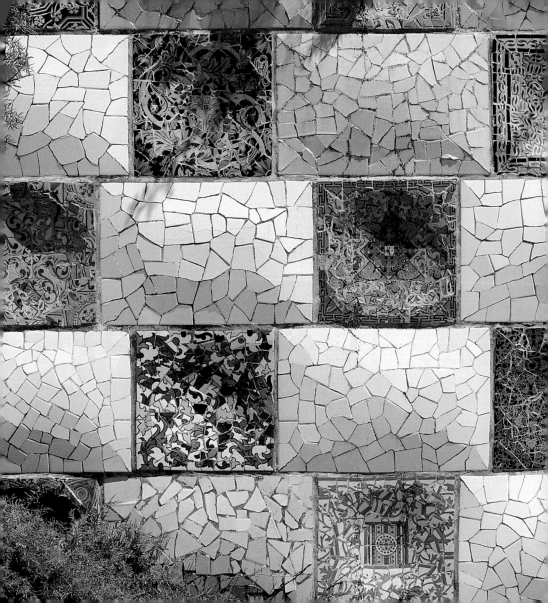

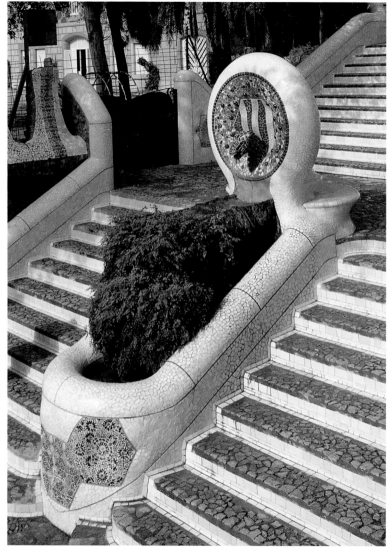

SECOND FLIGHT OF STEPS,
WITH THE CIRCULAR MEDALLION
ENCLOSING THE FOUR BARS
OF THE CREST OF CATALUNYA
AND THE BRONZE HORNED
SERPENT'S HEAD

HEXAGONS, THE SHAPE OF
HONEYCOMB CELLS,
SUGGESTING BUILDING,
COMMUNITY AND WORK. SOME
OF THE HEXAGONS HAVE
SUBSTITUTED THE ORIGINAL
MATERIAL, WHERE THERE WAS
A CHAMPAGNE GLASS AND THE
LEGEND "REUS 1898"

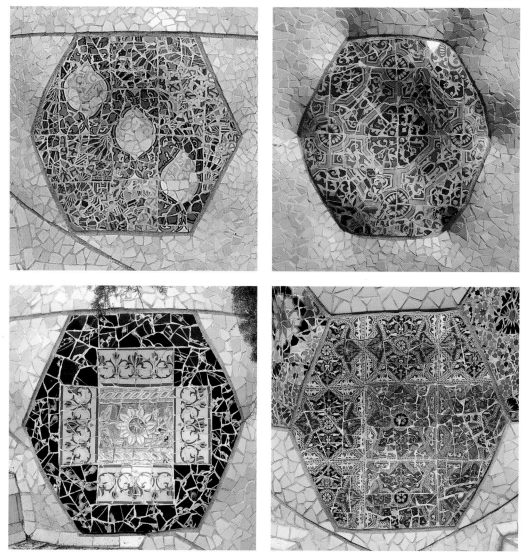

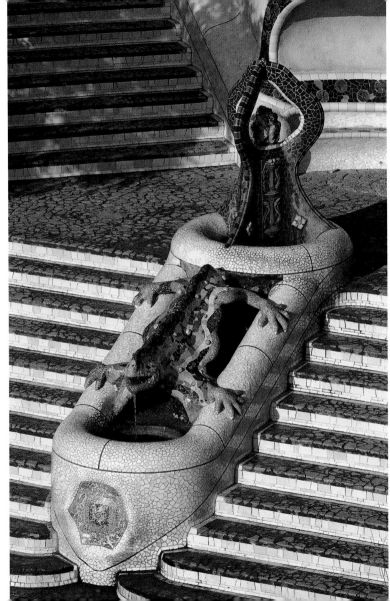

THIRD FLIGHT, WITH THE
ALCHEMIC SALAMANDER,
THE TRIPOD AND THE MOUTH-
SHAPED BENCH

THE WATER CASCADING FROM
POOL TO POOL AND FROM
ANIMAL TO ANIMAL ADDS LIFE,
AND CONTRASTS WITH THE WAY
OF THE INITIATE LEADING UP
TO THE TEMPLE

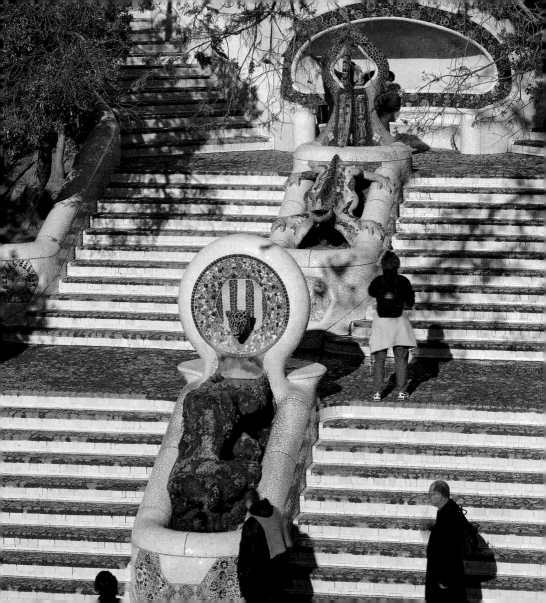

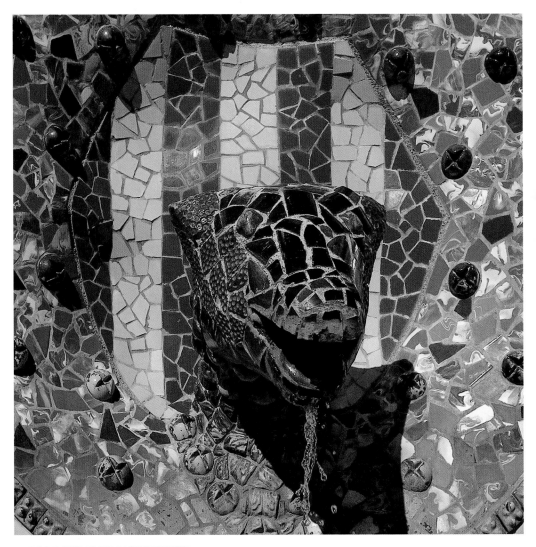

THE TWO SYMBOLIC ANIMALS OF THE STAIRWAY

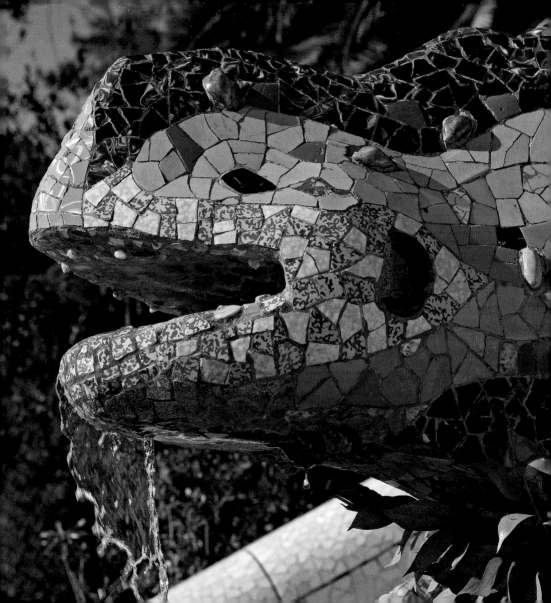

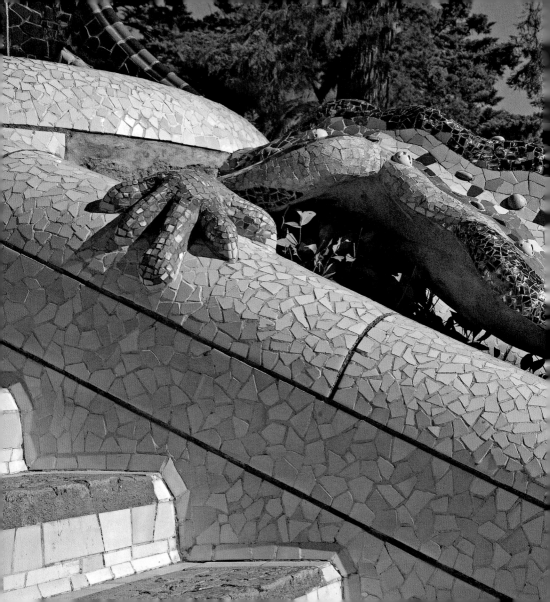

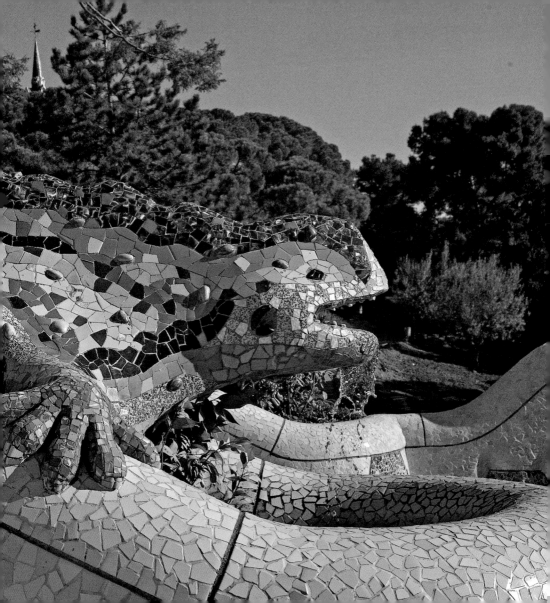

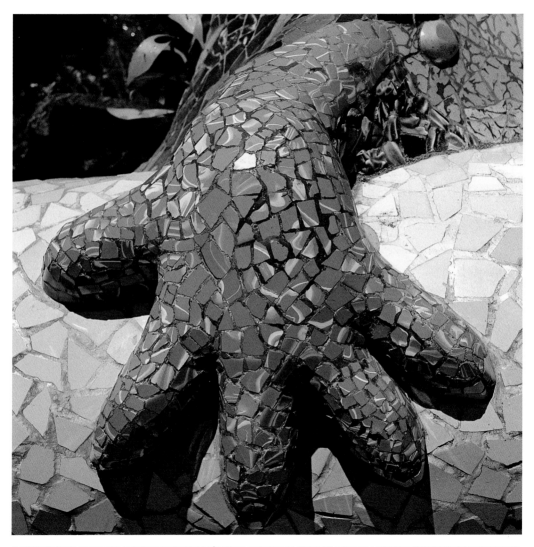

CLAW IN WHICH YOU CAN SEE THE QUALITIES OF THE TRENCADÍS MOSAIC AND THE BACK OF THE SALAMANDER, A CONTRADICTORY IMAGE OF WATER AND FIRE

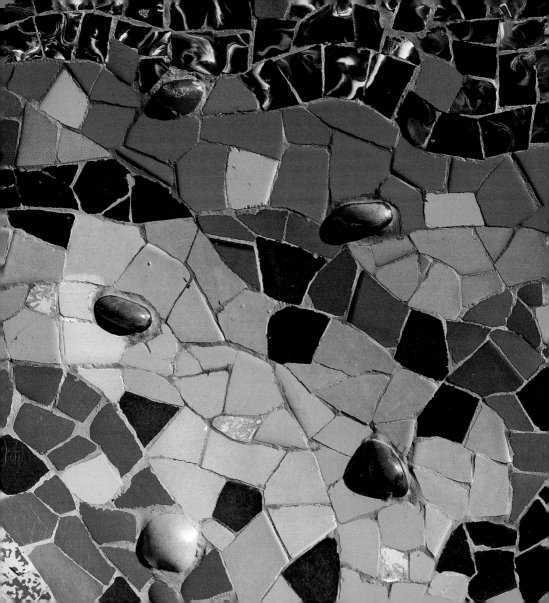

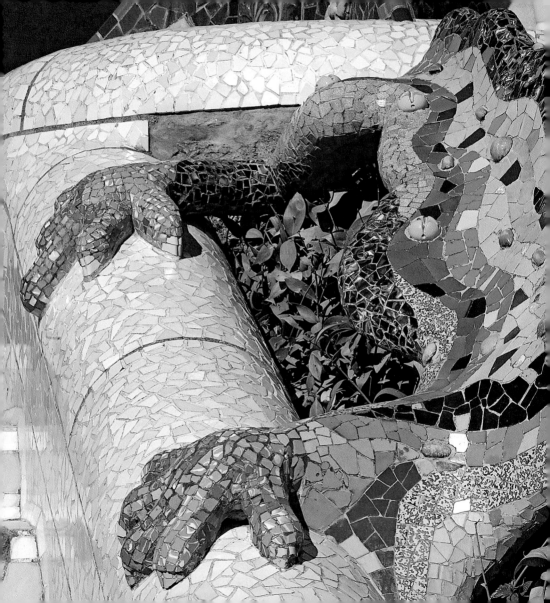

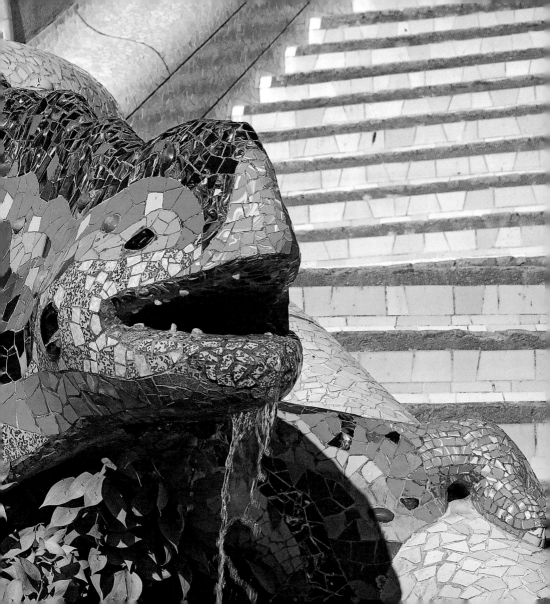

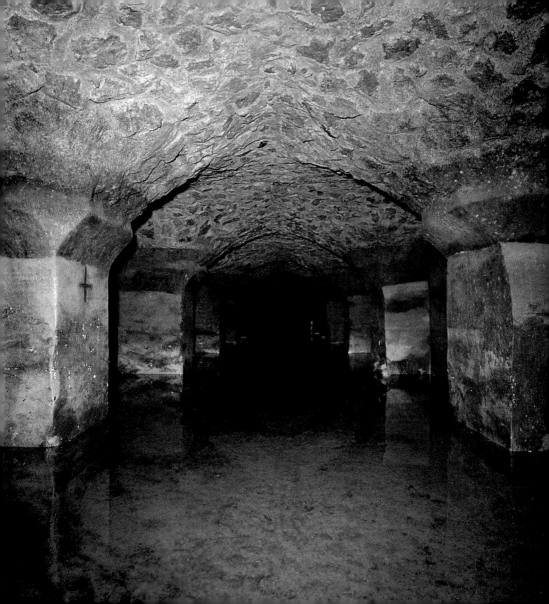

ENCHANTED WATER

The steps lead to the imposing Doric colonnade which supports the square dedicated to Greek theatre. When it rains heavily on the Park Güell, the water pours impetuously down the steep banks and paths and the square fills up with puddles. Before long the colonnade beneath would not be able to take the weight. However, contrary to expectations, given that the square is not cambered at all, the water does not lie there or overflow the sides demolishing the undulating bench. Thanks to one of Gaudí's ingenious ideas, the water filters through a bed of stones and sand which does not let the

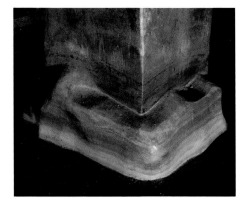

FOOT OF PILASTER

earth through and collects in the top of the columns to be led downwards through tubes inside the columns and flow into an enormous cistern. It is evident that the three spaces, the Theatre square, the colonnade and the cistern, are interrelated or linked by the rain, by water. And the same is true of the sculptures on the steps – the tripod/*omphalos*, salamander, and snake – threaded together by the waterfall. In twice times 3 paces, the water unites the sky and the earth with a chain of secret links rich in symbolic meaning and art.

NAVE IN THE CISTERN OR SHIP CUTTING THROUGH THE WATER, LIKE AN ILLUSION PLAYING WITH ABOVE AND BELOW, INSIDE OUT OR RIGHT SIDE OUT. LIKE A HERD. THE PILLARS ARE FEET HOLDING UP THE ELEPHANTS' BELLIES

The cistern was the first of these features to be built at the second stage of construction from 1906 to 1908. Its great capacity gave the community a degree of self-sufficiency, as if this were to be a city under siege – as indeed the enclosing wall suggests.

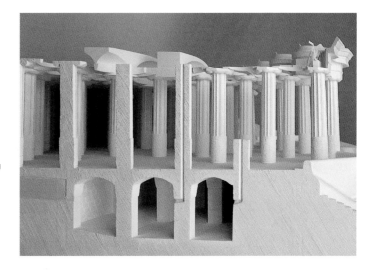

PLASTER MODEL WHERE ONE CAN SEE THE POSITIONING OF THE CISTERN, WHICH COLLECTS THE RAINWATER THAT FALLS ON THE SQUARE, CHANNELLED ALONG THE INTERIOR OF SOME COLUMNS

IMPRESSIVE CUBIST SCULPTURE ON A CAPITAL, LOOKING LIKE STONE WORKED AND EXTRACTED FROM THE UN-SHAPED ROCK, AS IN ALCHEMY

In fact, however, the water was not for drinking but for watering (irrigation) and other needs. The cistern occupies the right half of the hall enclosed by the colonnade, and the way down to it, not open to the public, is via a trap-door in the floor and a steep little ladder. Below, there are pillars of different heights, between two and three metres, some upright and others on a shapeless base, supporting rough stone domes – one has an incredible cubist figure at its root – leaving broad aisles as in a pagan temple. The pilasters have taken on a greenish gold hues which is as unexpected as a jewel in a well, and the capitals are black. The piles of stones at the feet of some of the pilasters – like those heaped on top of the Güell and Gaudí houses in the Park, are representative of Hermes-Mercury in the most primitive version.

Whether he was creating public spaces or hidden areas like the cistern where almost no one would go, Gaudí showed the same artistic zeal. The effect is even more impressive when one sees these green waters silent and still by the light of a lantern.

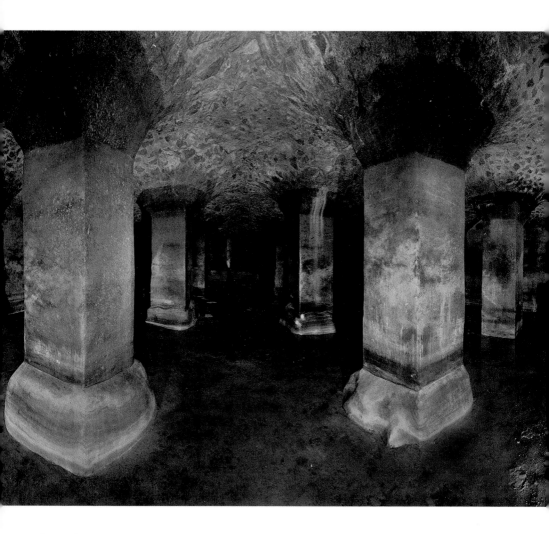

PILASTERS AND VAULTING OF THE CISTERN

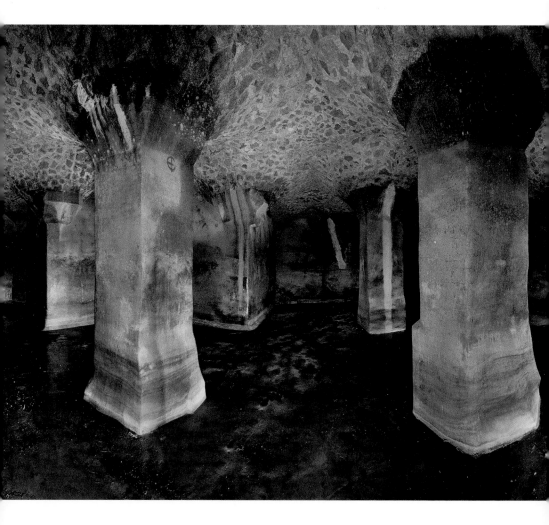

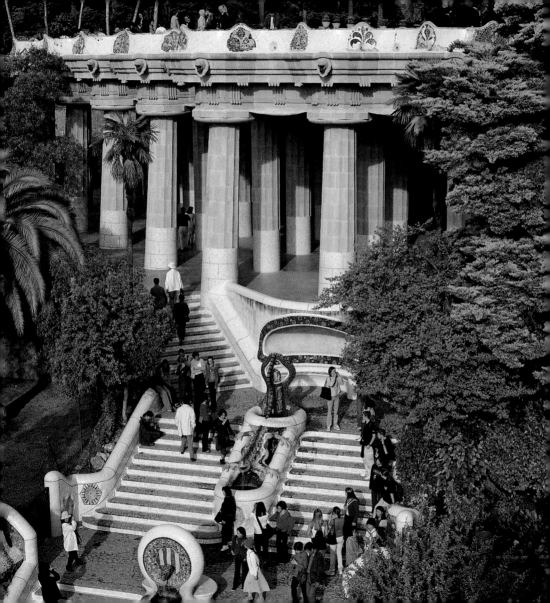

THE SUN AND THE MOON

The Doric colonnade was called a temple and a market, anticipating that vendors of goods would be attracted by the population of this little garden city. It's not surprising, then, that this is the most controversial of Gaudí's buildings. While some praise it as a tribute to Greece or a *revival* of the past[8]; others argue that its Helenic architecture is Vitruvian and baroque; still others see this as the least original feature of the Park[10], a wretched distortion of the Doric style, a cruel satire of classical art, a critique of nineteenth-century architecture[13], etc. However, it is perhaps worthwhile

CAPITAL SUNK INTO THE SHAFT

remembering that Gaudí himself said: "I have made the archaic Doric colonnade of the Park Güell as Greeks in a Mediterranean colony would have done it"[3], presumably suggesting that in such overseas settlements they built without too much rigour since they had only provincials to impress.

Notice that the outside columns lean inward to compensate the enormous weight of the square above, and that one of the most surprising innovations is that the columns seem to be stuck in the roof as if in a soft mattress. This marvellously absurd idea had already been touched upon by the poet Ovid in Metamorphoses, when he said that in the origins of the world: "The earth was not solid, the water was not navigable and there was no light in the air" and added

WRITERS LIKE J. BASSEGODA, BERGÓS, BOHIGAS, MARTINELL, PANE, RAMÍREZ, SOSTRES, ETC. HAVE KEPT UP THE CONTROVERSY FOR OR AGAINST THE COLONNADE

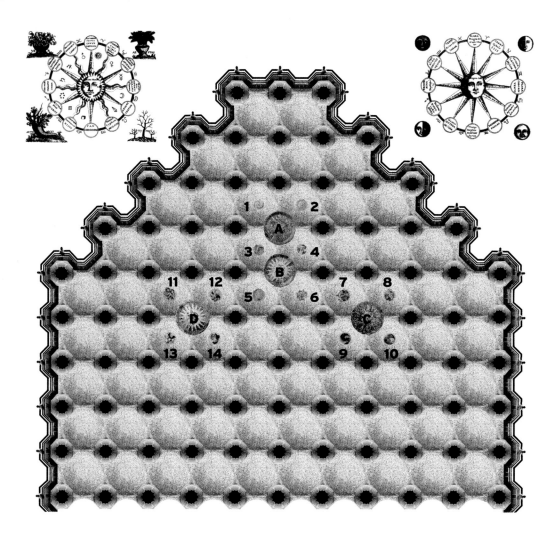

PLAN SHOWING THE 86 COLUMNS. SOLAR PLAFONDS (WE WILL CALL A THE SUN IN SUMMER, B SUN IN WINTER, C SUN IN SPRING AND D THE SUN IN AUTUMN), AROUND THESE ARE THE MOONS (1 TO 6 AROUND A AND B, 7 TO 10 AROUND C AND 11 TO 14 AROUND D). IN THE INSET, OLD ENGRAVINGS OF THE SUN WITH THE 4 SEASONS AND THE MOON WITH ITS PHASES

that "no body had a stable form, so that the cold fought with the hot, the wet with the dry, the soft with the hard, and that which was heavy lacked weight."

The colonnade is an imposing space formed by 90 massive columns: 3 in front, 5 in the second row, 7 in the third row, 9 in the fourth, and 11 in each of the six rows at the back. However, as Gaudí omitted to construct four of them, one in the fourth row, one in the fifth row, and two in the sixth, this reduced the number to 86 [12]. This number is a module or constant in the park, since the square above it is 86 metres wide, the sum of these figures is: 8+6=14 and 1+4=5. It seems improbable that Güell would instruct Gaudí to remove 4 columns and on the other hand it is very probable, that, as in other apparent changes made by Gaudí, the object was to conceal the real intention: the figures and the calculations based upon them.

The coloured plafonds

Where the columns had been taken away, a round plafond, two or three metres in diameter was placed in the roof, as was done in ancient times in the temples and then later in country houses. These are among the most famous Gaudian objects, made from pieces of porcelain, stone and glass [22].

It would be useful to describe the plafonds, something which is not often done, and the first thing to notice is that the four large plafonds are all basically the same, although in varied materials and colours. The outermost one (A) is quite thick, with a bright blue background and a greenish area; with a golden 20-pointed sun, long rays alternating with short ones. Inside the sun a long, narrow white ribbon is to be seen, formed into a loop on right, with another identical but opposite on the left. The ribbon itself is almost straight in the middle, where there is a hook for hanging a lamp; and at each side there are slanting white templars' crosses.

There is some discussion as to whether the plafonds are by Antoni Gaudí or by his young assistant Josep Maria Jujol, and the standard answer is that those designed by the master were,

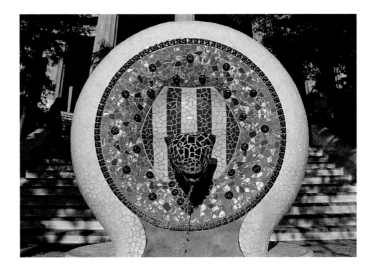

MEDALLION OF THE STAIRWAY

SALAMANDER BY THE YOUNG GAUDÍ
IN CIUTADELLA PARK

STRIP DECORATING THE SOFFITS OF THE
COLONNADE, MADE BY JUJOL

until then, more geometrical and those done by Jujol were freer in style with a livelier sense of colour [15]. But that is not enough. The above-mentioned round medallion on the steps, featuring the coat of arms of Catalunya is evidently by Gaudí, since it is more geometrical. It will be seen that its sky blue colour is similar to the ones in the roof of the colonnade, and that the colours in the centre are similar in each case. This would suggest the following interpretation of the plafonds and their significance: the sun bursts into the heavens and fills the world full of colour, under the protective sign of the snake and the cross. And since the Catalunya medallion is earlier and clearly by Gaudí, the following conclusions can be drawn: the idea, colours, materials and structure of the plafonds are the master's, while the actual execution, the colours and the shapes themselves are by Jujol.

But the whole takes on greater richness if one remembers one of the earliest of works by Gaudí, as a young man for the aquarium in Barcelona's Parc de la Ciutadella: a round, stone plafond, with a naturalistically drawn salamander poised obliquely in the centre, flanked by

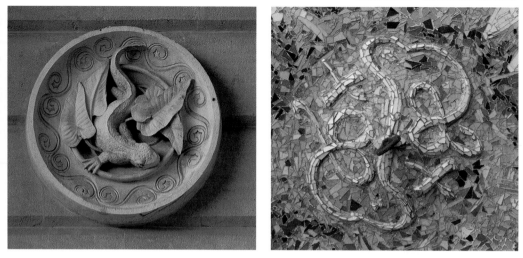

leaves, two on the left side and two others, inverted, on the right. The arrangement of the different elements is very similar to what we see in these plafonds, although without suns or crosses, with the salamander replacing the ribbon and the hook. And the similarity is even greater if the undulating and spiral decoration of the stone disk is compared with the border of the plafonds in the ceiling, only visible when viewed from the side. This, then, is a design dating from Gaudí's youth which, as is the case with many creative artists, reappears transformed in his later work. "The only fertile way is repetition", said Gaudí, "in Beethoven there are themes that are repeated from ten years earlier, and we find the same thing in Bach; the Catalan poet Verdaguer always copied and improved his poetry"[3]. It seems irrefutable that the plafonds were thought out in all their detail by Gaudí, in consultation with Güell and the work magnificently carried out by Jujol.

The four suns correspond to the four seasons. In the forefront (A), we have already mentioned: the sun of the summer solstice, a blaze of light and colour; behind it (B), there is the

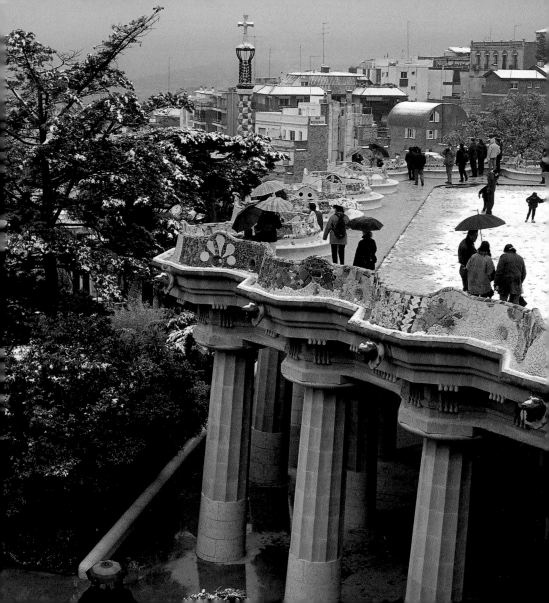

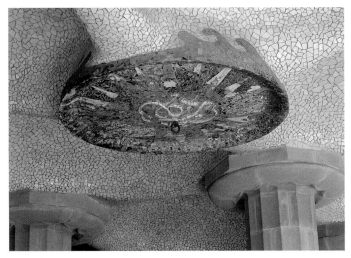

THE AREA OF THE COLONNADE WAS DESIG-
NED TO BE A MARKET

EDGE OF SOLAR PLAFOND

sun of the winter solstice, cold, lifeless, and the other two, at the back, are of course the equinoxes, with the vernal equinox on the right (C), and the autumnal one on the left (D), a mixture of life and death.

As interesting or more so, aesthetically, are the small plafonds, 14 of them, suggesting the moon with its phases of waxing and waning, the lunar month and the female cycle of 28 days. In the corners of the large plafonds the lunar rosettes are little glazed ceramic windmills and spirals, more or less circular and regular in shape, with two to four arms in opposite directions, to indicate that when a spiral rotates in one direction it appears to rotate in the other.

Those in the front are light green in colour, pearl-tinted silvered glass, or palely dreaming moon, of a rare beauty and ambiguity. Those at the back, on the other hand are more varied and intensely coloured. Furthermore, those in the sixth row appear to be figurative, and – in the case of the ones on the right, with their bright colours – correspond to the vernal equinox, when the angel announced the Incarnation to the Virgin, whose sign was a

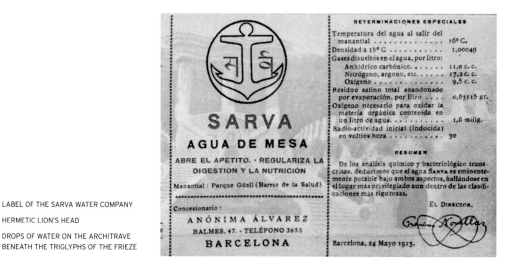

LABEL OF THE SARVA WATER COMPANY

HERMETIC LION'S HEAD

DROPS OF WATER ON THE ARCHITRAVE
BENEATH THE TRIGLYPHS OF THE FRIEZE

red star. The dappled chiaroscuro cross accepts the death of the Son, which purifies Woman, both the alpha and omega of Life. In contrast, the autumnal equinox has a little girl playing at home with an elegant slim doll, in front of her are bottles of women's perfume, and all this is depicted against a background of cold tones. Next to the girl, like a warning or menace to man, swims a deadly jelly fish with 7 blue and green arms, beautiful and light, dirty and sinister, drawn in and yet ready for furtive vengeance, which Gaudí apparently expected and feared in women.

This then is the Cosmic *Temple of the Sun and Moon*, of the masculine and feminine principles, of the light and its reflection, of reason and feeling, of night and day, of this world and the next. Thus it is that the foreground of the Temple is luminous while the background is shadowy and unsettling. masonic temples are for this reason presided over by images of the Sun and the Moon [25.] All the same, it is a little strange that any one should want to use the colonnade as a market place for everyday goods. But for Gaudí, merchants were akin to architects and artists in general,

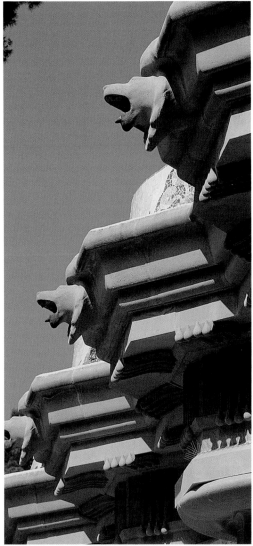

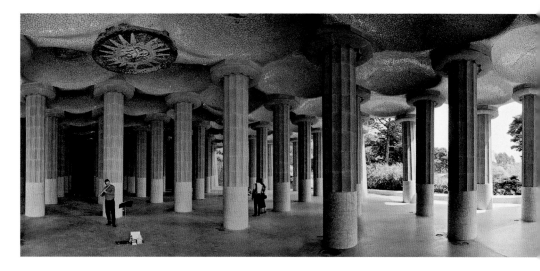

since "they typically have an overall view of the issues they are concerned with", unlike the analysts, who only have fragmentary knowledge [3] (compare the blind men and the elephant). Now the god of commerce is Mercury, *Merx*, from which come the words market (Spanish *mercado*) and merchandise (Spanish *mercancía*) and so this temple is also dedicated to Hermes-Mercury. This god carries a staff from which hang white ribbons (or snakes) as we have already seen with the Sun, and the lions' heads on the outside of the enclosure are in this case, emblems of the art of Hermes, or the secret knowledge.

At the far end of the hall of columns there was a spring of water with traces of magnesium, compared by some to the Castalian spring in the sanctuary at Delphi, because of the analogy they saw between the two places, and this too drained into the cistern. Güell put this water on sale and called it *Sarva*, as can be seen from the labels on the bottles, with an anchor and two letters of the *devanagari* script traditionally used for Sanskrit. Sar and Va are the two initial letters of Siva and Vishnu, the gods that represent the totality when

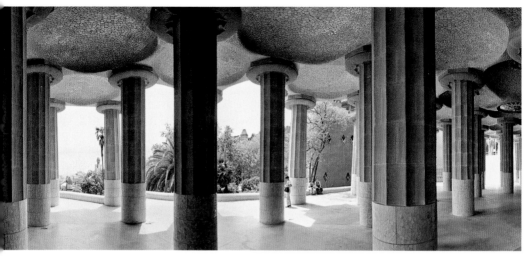

united, like Alpha and Omega, beginning and end, referring to God[2]. But Sarva appears in the Bible as a widow, the mother of Jeroboam, commander-in-chief of Solomon's fortifications. And there are famous widows, the greatest of whom was the Egyptian goddess Isis, the widow of Osiris, and for that reason the masons call themselves "sons of the widow". This is the name Güell chose to call the medicinal water which he wanted people to have in their homes, in his disinterested philanthropic campaign in favour of public health.

Among the lions' heads, there are groups of drops about to fall which are directly above the storm drains from the bench, so that a direct (if strange) link is set up between the modernity and colour of the bench above, and the ancient, colourless, hieratic nature of the colonnade. Gaudí said on repeated occasions that the temples of classical times were painted in bright colours, and felt that a lack of colour is synonymous with a lack of life[3]. The colonnade is a great construction, rich in symbolism and occultism, but it is also a typical sample of the architecture of its time, drained of colour and substance.

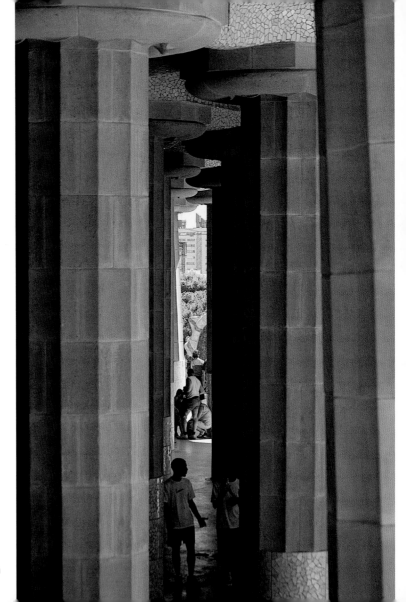

THE COLONNADE COLLECTS
THE RAINWATER THAT FALLS
ON THE SQUARE AND
CHANNELS IT TO THE CISTERN

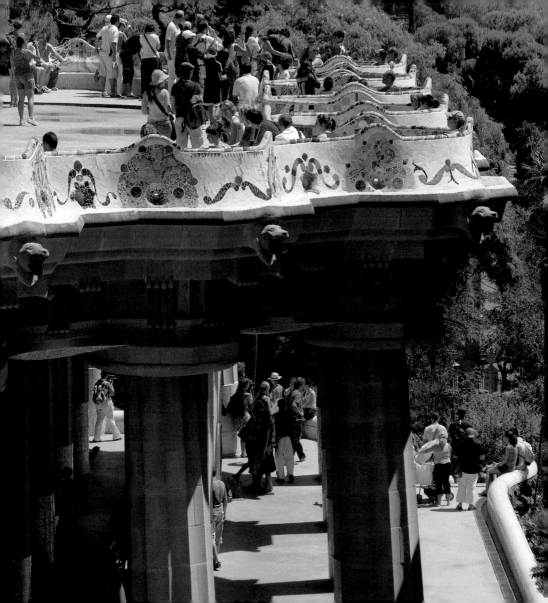

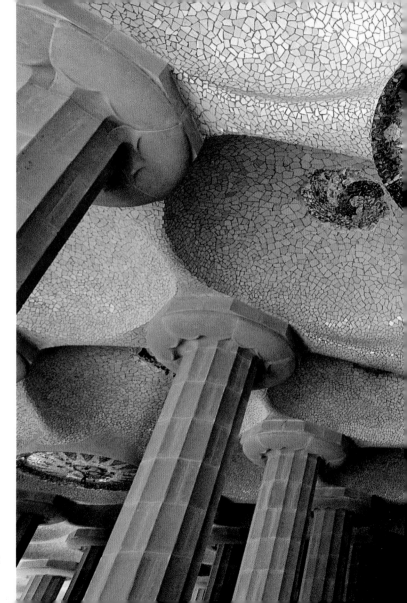

TEMPLE OF THE SUN AND THE
MOON, DAY AND NIGHT

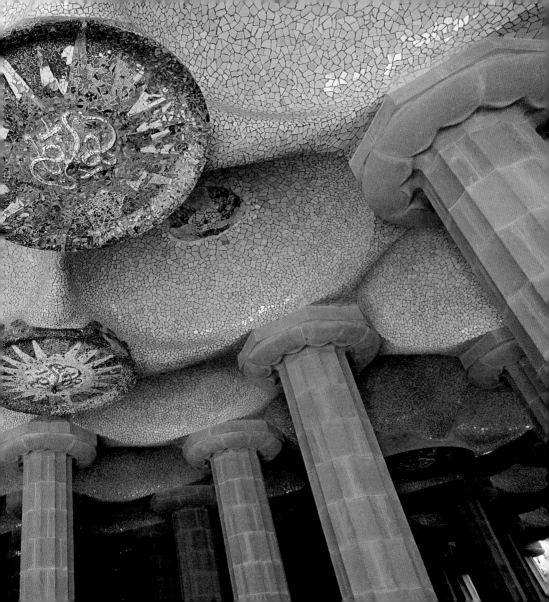

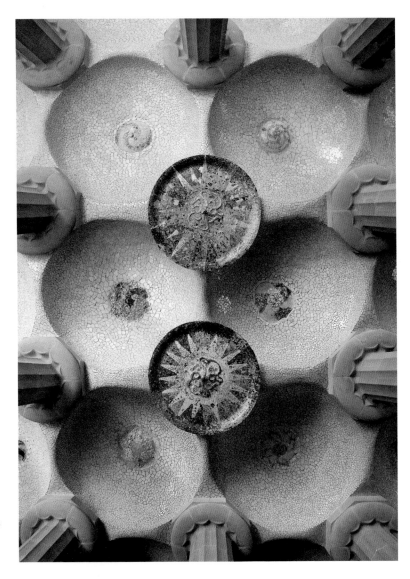

SUMMER SUN (A) WINTER
SUN (B), WITH THEIR MOONS
(1 TO 6) IN A SPIRAL, THE
SIGN OF ARTEMIS, SISTER
OF APOLLO THE SUN

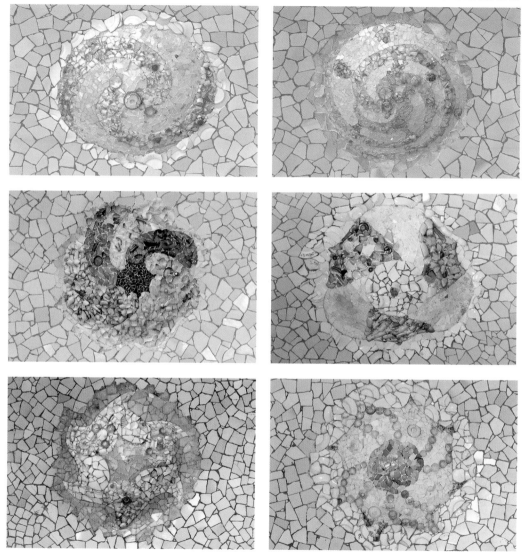

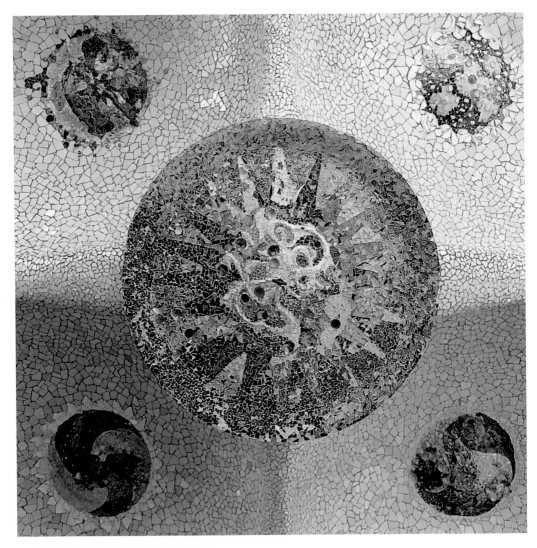

SPRING SUN (C), WITH ITS MOONS AROUND IT (7 TO 10)

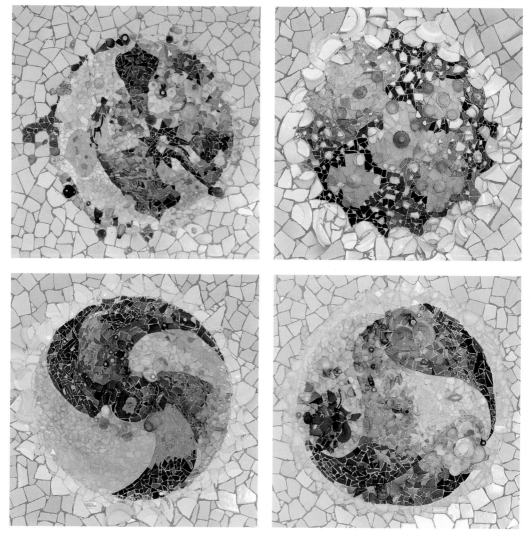

SPRING LUNAR SHIELDS (7 TO 10): CROSS WITH BONES AND STAR. INCLINED CROSS. 8-COLOURED SPIRAL. AND THREE-ARMED SPIRAL

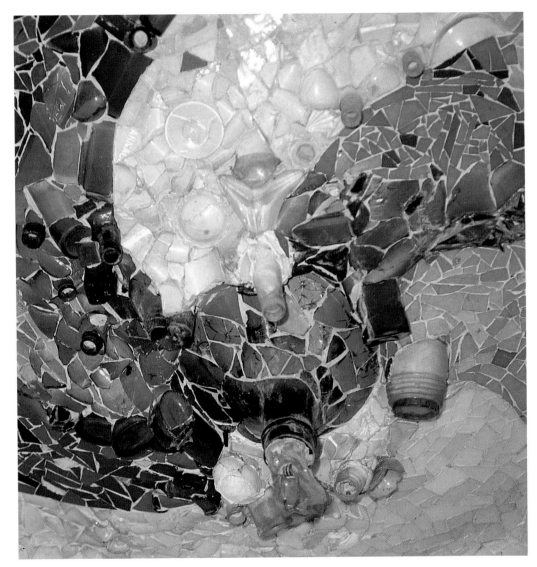

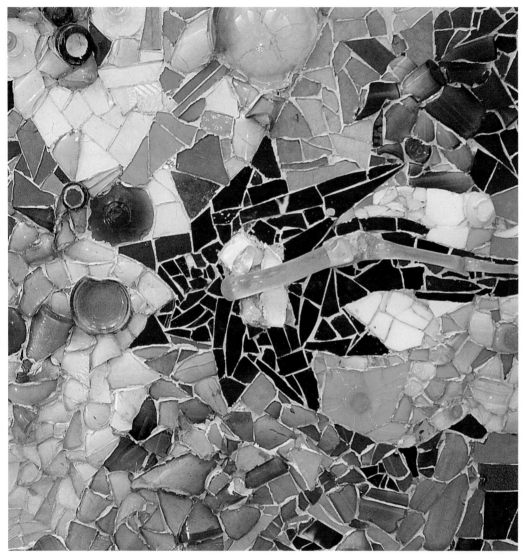

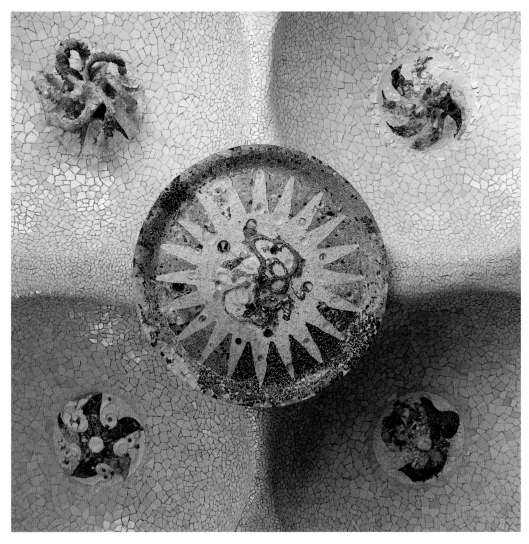

AUTUMN SUN (D); WARMER COLOURS THAN THOSE OF THE WINTER SUN

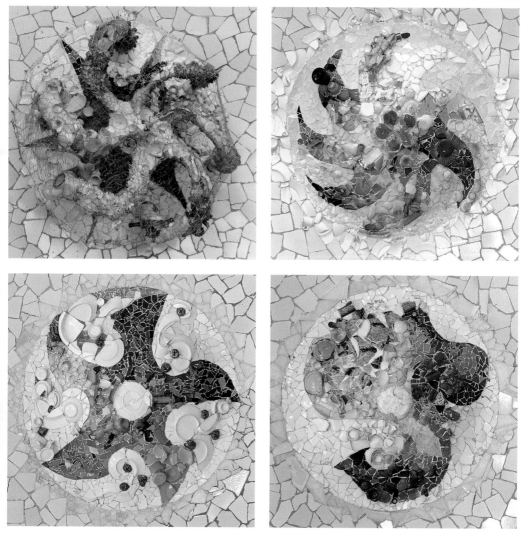

LUNAR SHIELDS (11 A 14), IN AUTUMN, WITH MOTIFS: THE DREADED MEDUSA, SHARP SPIRALS WITH BROKEN PLATES, AND THREE SHAPELESS ARMS

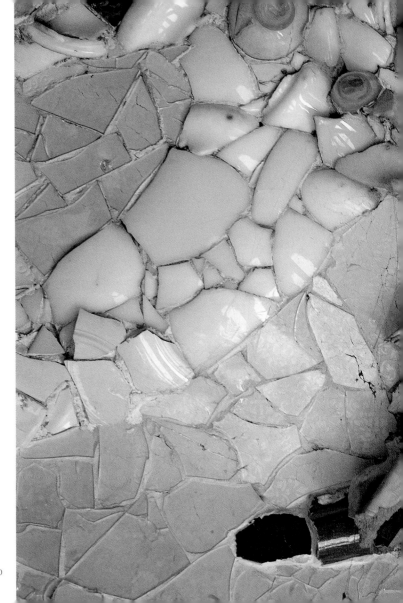

DOLL IN THE LUNAR SHIELD (12)

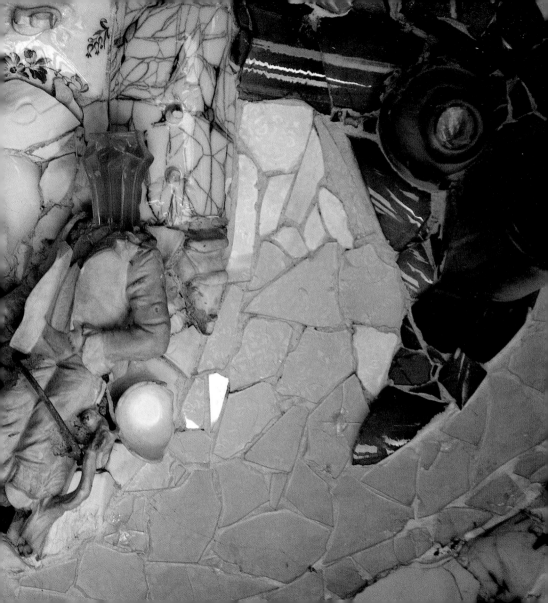

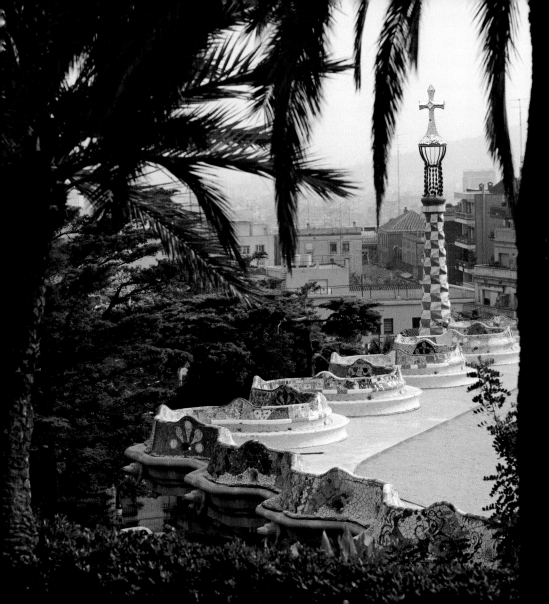

THE THEATRE VIRUS

Directly above the colonnade is the colony's main square, referred to as the Greek Theatre since the earliest days. The square is bounded on the lower side by the great undulating bench, and on the upper side by the palm tree avenue, where some of the trees are real, and some others are made of stone. The latter have a rustic stone rail around them so that there is a certain formal similarity with the wavy bench and its tight curves forming "theatre boxes" where groups of people can gather.

The back rest of the bench

Scarcely resting against the outside columns of the Temple, the bench is a marvel of engineering, poised in the air, almost without visible support [10]. Even before reaching the square

by way of the steps, one sees, at eye-level, the outer part of the bench, decorated with five-branched palm trees as in the acroters which crowned the classical temples. Thus the acroters (scroll-shaped pedestals) and bench form a whole, as does the triad formed by the cistern, temple and square.

Notice however that the acroters in the central part of the bench show the palm fronds evolving, transforming through a series of designs into a sort of spider, and then vice versa, becoming a little palm tree again. But the most fascinating thing is that the more one looks at these designs the more one seems to see a metamorphosing crab with powerful claws in different positions – including frontal, with piercing eyes

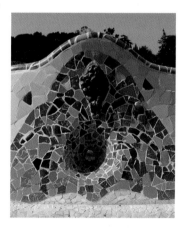

THE SPIDER, A STAGE IN THE METAMORPHOSIS OF CANCER THE CRAB, GAUDÍ'S ASTROLOGICAL SIGN

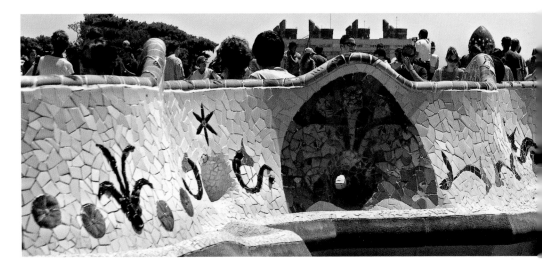

and formidable pincers – and this actually has you doubting whether the plant-like appearances of the preceding designs were real or not. But the crab is the sign of the zodiac for Cancer, the house where the sun reaches its plenitude before daylight hours begin to decrease again. The crab's way of walking backwards and the contradiction in the way the sun recedes as it advances is represented by the symbol for Cancer with two circles, the top of the lower circle joined to the lowest point of the upper circle, so one is in the opposite position to the other. The plafonds decorated with the salamander that we mentioned earlier, designed by the young Gaudí, precisely combine the motif of the waves returning back on themselves in a dynamic circle, in the manner of the stereotyped architectural frieze but richer and more vital – and something comparable happens with the leaves. The same pattern appears at various places on the outside of the bench, above all in the figures between one acroter and the next: large separated blobs each inverted in relation to the next, but united by their dark colouring in pairs. But Cancer was Gaudí's sign. He was born in Reus at 9.30 in the

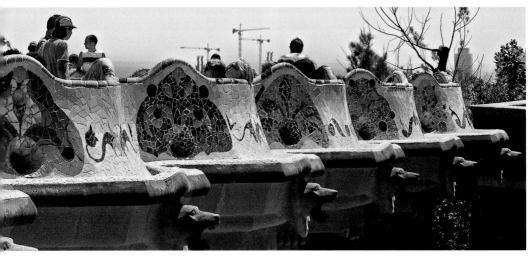

morning on 25th June, the summer solstice of the year 1852. That this sign takes up the centre underlines the need that this (otherwise very modest) architect had for self-affirmation. and for playing the star role. Furthermore, at the top of the backrest can be seen pairs of red rhomboids and deltoids which relate to the sign of Cancer, indicating as they do the feminine: the door or vulva through which souls enter the earthly life at the time of incarnation. The lunar feminine element is very evident in Cancer, and Gaudí wanted to underline this fact. In the great zodiac on the main façade of the church of the Sagrada Familia, relating precisely to the Annunciation or Incarnation, the sign of the crab occupies the top position in the circle of signs. It is placed there because this is its correct place, but also because of its ability to attract your gaze.

To one side of the metamorphosis of the crab there are other signs, such as the horns of Capricorn, the bow of Sagittarius flanked by coloured arrows, and the horns of Aries, while on the other there are the two Pisces fish facing one another. And on the inner side of the bench, there are Libra,

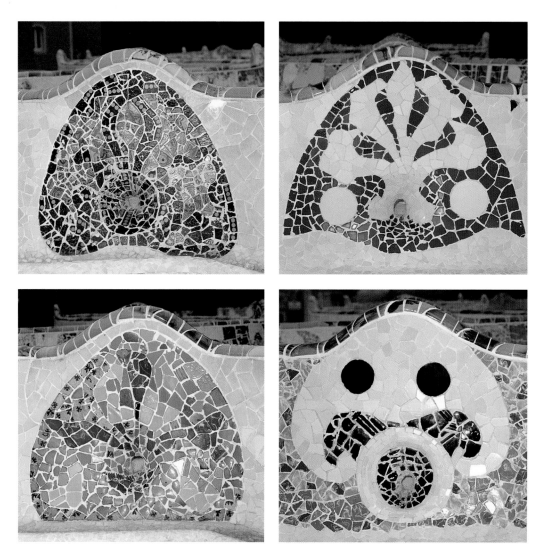

STAGES WITH DIFFERENT BACKGROUNDS AND SHAPES AROUND THE STORM DRAIN

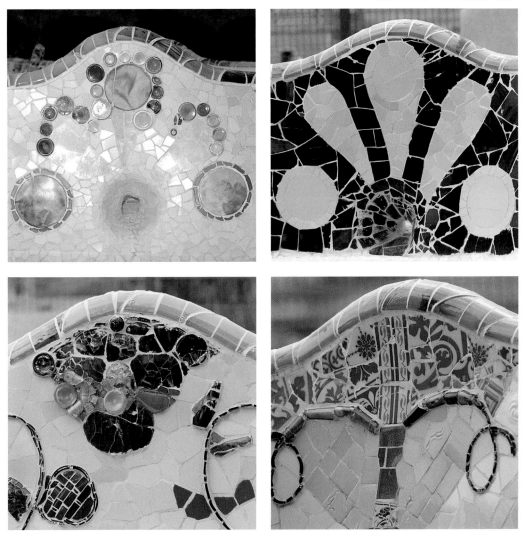

THE TRENCADÍS ALLOWS FOR INNUMERABLE VARIATIONS, IN SIZE, COLOUR AND MATERIALS, ON FLAT AND CURVED SURFACES ALIKE

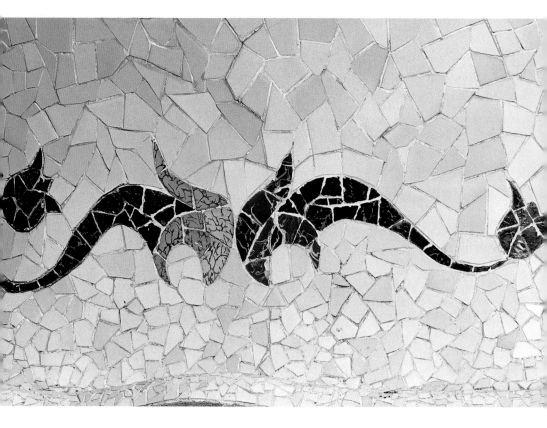

FACE-TO-FACE FISH: THE SIGN OF PISCES FORMED BY THE TAILS

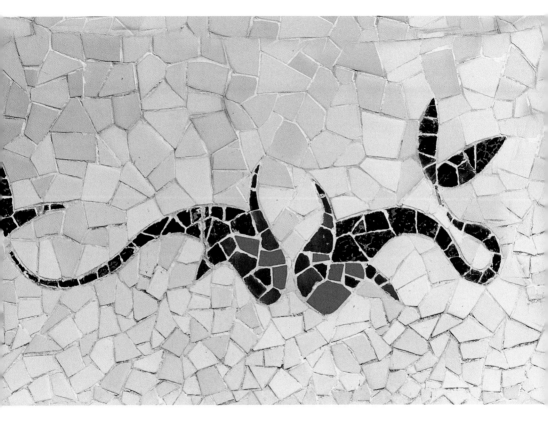

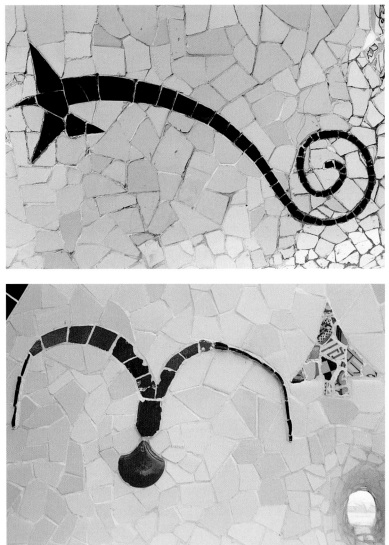

STAR WITH TAIL, OR WITH
ELEPHANT'S TRUNK

BENT BOW AND ARROW HEAD IN
BRIGHT COLOURS: SAGITTARIUS,
THE ARCHER

DETAILS OF THE TRENCADÍS
MOSAIC DECORATION

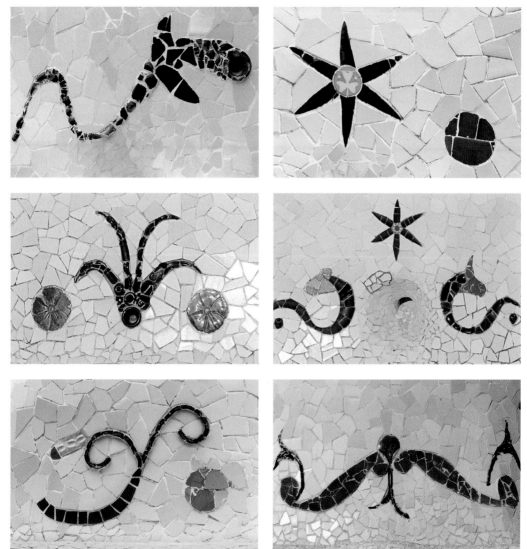

Virgo, etc., such that all the signs of the zodiac are represented. At the far ends on the outside there are more patterns to be seen, this time freer and more informal, full of fantasy.

The undulating bench

In creating the bench, Gaudí studied what the most comfortable version would be for users, and had a young workman sitting for him. Jujol, in turn, painted and prepared the ceramic pieces for their firing in final form. At the same time, some modules or segments of the bench were made a metre and a half long; these were joined together, with due adaptations for the curves, since these are not all the same, and then the ceramic pieces were stuck on them, striking them with a mallet to break them up and adapt them to the shape of the module [12]. Once again the concept, structure, materials, content and ideas were from Gaudí – assisted by certain craftsmen – while Jujol entered fully into the matching of the colours, shapes and combinations of both. And, as with the pavilion roofs, but in a more varied and complex way, Jujol used pieces of all sorts, including from his own dinner service (with cherubs) or from the Trías family china to achieve more striking effects.

The bench, wavy like the sea itself, might well have had for Gaudí and Jujol a close link with plates in their memories of fishing in the sea off the plain of Tarragona. In talking of the Tarragona resort of Cambrils in his book *Catalunya des del mar* (Catalunya from the sea) Carlos Barral writes: "It was the custom, formerly, to throw pieces of white china, broken plates and the like, to the fishes as ground bait. These fragments were put aside for this purpose instead of being thrown out. The small tuna fish, excited by the shiny pieces of crockery, would frolic about on the surface giving the impression that the water was boiling".

The bench is a marvel, unequalled of its kind, in its shape, colour, luminosity, imagination and contrasts, a blend of low and high art seldom achieved in other works of abstract art or

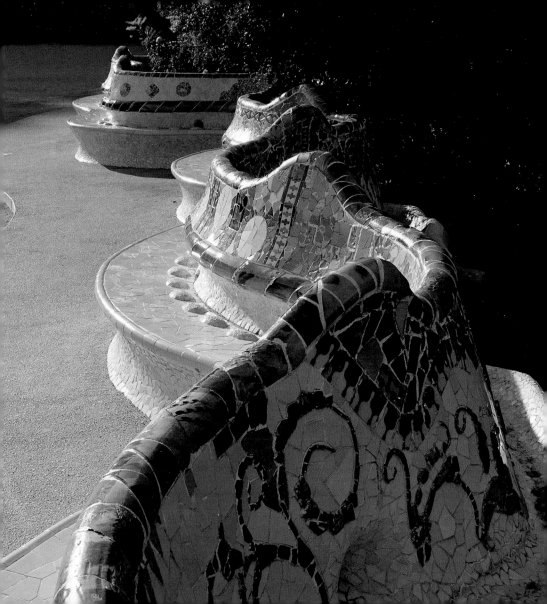

collages[15]. Unfortunately, the freedom that users now have to approach this work and admire it in all its variations and detail is to a considerable extent negated by the tremendous loss of large parts, destroyed and replaced with white ceramics, made worse by the fact that the avalanche of visitors means some can furtively break off a chunk or commit other acts of vandalism.

Inscriptions

Connected with the foregoing, although of a different order, are the inscriptions by Jujol, in Catalan or Latin, plus other signs at various points on the bench. Neither structural nor decorative, they are virtually *graffiti*, before such ephemera were accepted as art. Deliberately cryptic, placed where they are least likely to be seen, they appear to be in an inexpert hand, and half a century had to go by before they were discovered. The fact that the writer seems inept is just another ploy used in secret writing, since in reality several different types of handwriting are used, some very innovative. There is also a contradiction in the way that they were written before the glazed ceramics were fired, indicating that they were meant to survive, yet many of them are repeated, as if to underline their insignificance. Some, sadly, have vanished: "Reus", for instance, the town where Gaudí was born, and "Marta i Maria" (Martha and Mary), after the sisters who gave Jesus lodging. Martha was, as we have said, the patron saint of hostelry and innkeeping. Other references to the Virgin on the bench lead one to think that she tramples the serpent – in this case the serpentine bench – underfoot in the same way that Mary was, like Aesclapus, the healer and saviour of humanity. Thus one can read "Oh María", "Angelus Domini nuntiavit María" (the Angel of the Lord announced unto Mary), the annunciation being a dominant theme in Gaudí's thinking. But others are ambiguous, like "Ay urbs antiga i atresorada" (alas, ancient city rich in treasure), "tum serveixes" (you serve me)., "Tum somrius?" (do you smile at me?", "Sos ulls" (her eyes), "Sos front" (her forehead), "fora gelosía" (begone jealousy)[18]. An intriguing hypothesis is that since some of the writing runs in one direc-

"AB ELLA VIA DE PAU" (WITH HER, THE WAY TO PEACE)

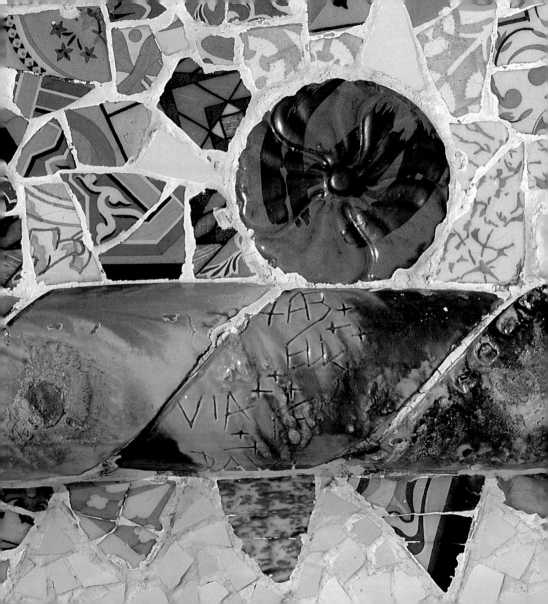

tion and some in the other, this could be a dialogue between the Virgin and the Believer, in which the Virgin speaks the part which is written backwards. Most of the surviving inscriptions follow this pattern, although some are less obviously dialogue and are in the third person. Apart from this, it should be noted, given that astrology is utilised throughout the Park, that Josep Maria Jujol was born in Tarragona on the 16th September 1879, under the sign of the virgin (Virgo).

The bench's long, tortuous, undulating shape is certainly curious. However, in theatres and opera houses it is usual to have boxes separated by partitions that take the same form as half the bench's undulations. This, linked with the fact that in many languages the term for theatre box is lodge or loggia gives us a clue to what Gaudí intended to suggest here.

It has already been mentioned that the Park was conceived with health in mind

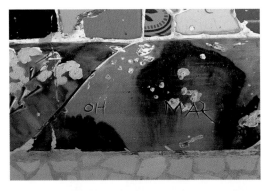

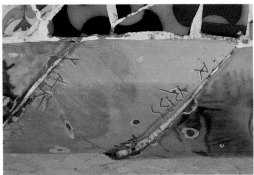

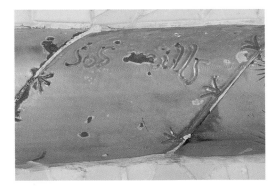

"OH MARÍA". "M" WITH CROWN. "ANGELUS DOMINI NUNTIAVIT MARÍA". "AY URBS ANTIGA I ATRESORADA.". "TUM SOMRIUS?". "TUM SERVEIXES". "SOS ULLS". "FORA GELOSÍA". "SON FRONT"

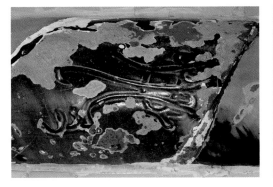

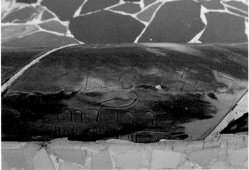

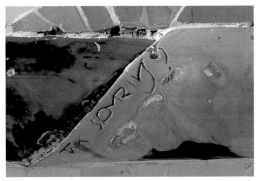

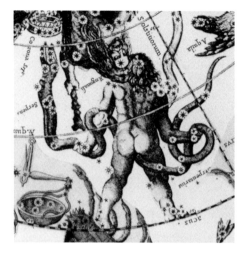

AMIDST THE HEAVENLY CONSTELLATIONS, THE SERPENT, GRASPED BY OPHIUCHUS, THE SERPENT BEARER, TAKES THE SHAPE OF THE UNDULATING BENCH

and that the two opposing snakes at the entrance represent health and medicine. The same thing is expressed by the snaking, serpentine paths and reaches its culmination in the bench and the portico. This, then, is why the bench is so large. so long, colourful and lively. The snake is one of the most magnificently suggestive symbols in the theogonies of the world: it is the Totality, Nature, the World, God. In the Park, too, it has this range of meaning, especially Nature, in all her positive and negative aspects. According to Greek mythology, Aesclepus became the god of Medicine, like his father Apollo, and so great was his wisdom that many came to his hospital sanctuaries, in Epidaurus for instance, seeking to be healed by the priest physicians. They did so using baths and exercises, medicinal plants and psychic influences, based on diagnoses often informed by dreams. For all the benefits he brought, a heavenly constellation was dedicated to him, the constellation Ophiuchus, the Serpent Bearer. As a glance at a star map will show, this group of stars has the constellation of the Snake superimposed on it, so that the Bearer grasps the Snake with two widely separated hands. For that reason the celestial Snake takes the form of a very broad U. This is in fact the shape of the undulating bench itself, whose ends – head and tail – seem to wave about and grasp the large flower pots placed there. All this stands for the fact that Aesclepus subdued the serpent and placed it at the service of his humane arts.

THE OVERALL SHAPE OF THE BENCH
SUGGESTS A SNAKE FOLDED IN THREE

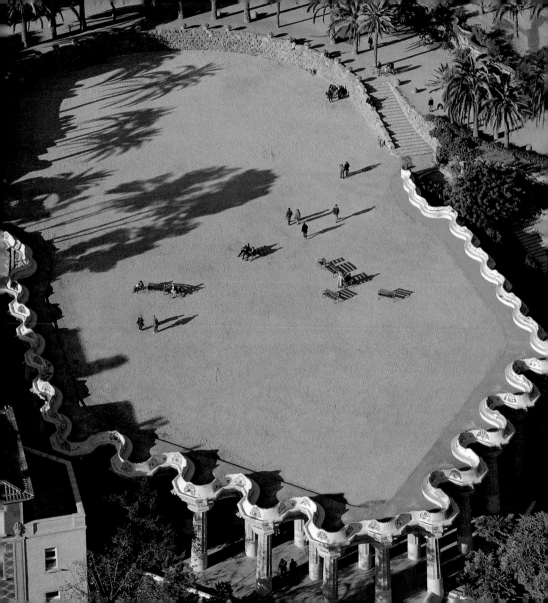

Theatre and health

Eusebi Güell, the philanthropist, threw open the Park whenever he was asked for reasons that he thought worthy, and his spectacular parties filled the enclosure full to overflowing, as can be seen from photographs of that time. For example, in 1906 there was the first International Conference on the Catalan Language, bringing together specialists from different countries; in 1907 the benefit event held by the Autonomist Associations on behalf of flood victims in Catalunya, with groups of young people collecting donations from the thousands of people present; in 1908, the festival with dances and a race which started in the Carrer Olot and finished on the Turó de les Menes (highest point in the Park); in 1909, another beneficent function had military bands, *sardanes* (traditional Catalan ring-dance), puppets, balloons going up, bicycle races, pretty lasses selling sweets and wines and a swarm of motor cars and carriages of all kinds moving around the broad avenues; then again, in 1911, the event organised by the Women's Federation against Tuberculosis, to present awards to school children for outstanding personal hygiene, and so on.

It seems that several plays were put on at the Greek Theatre, but we only have a record of the plans for one. There have always been performances in the open air, but the renovation of old theatres to put on classical plays dates from 1888, when Paul Marieton staged Sophocles' *Oedipus Rex* in the Roman theatre at Orange in Provence[24]. So great was its success that there were soon imitations everywhere, even in places with no old theatre, and not just in warm temperate climates but in central and north-west Europe too. When there were no old ruins to justify it, advantage was taken of a sheltered outdoor spot, duly renamed Theatre of Nature. In Catalunya this was pioneered by Adrià Gual, with Goethe's *Iphigenia in Tauris*, translated into Catalan by Joan Maragall and performed for the first time on 10th October 1898 in the labyrinth gardens, near Park Güell. In the years that followed there were other plays of this kind, but people either in jest or in earnest called these "al fresco theatre", and were critical of the awful acoustics. The successors to these were the open air theatres.

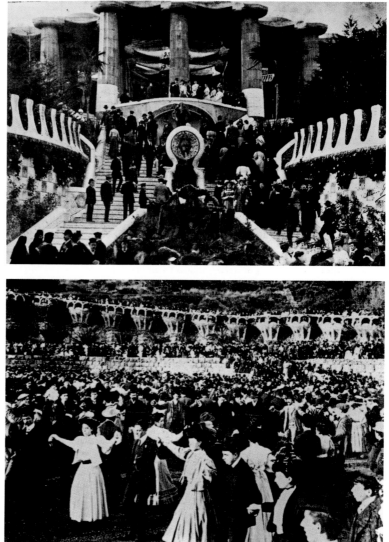

THE CHARITY EVENT FOR FLOOD
RELIEF IN 1907 FEATURED
CHOIRS AND SARDANA
ORCHESTRAS

NOT JUST FOR PARTIES.
THE SQUARE WAS USED FOR
FOOTBALL, TENNIS, RACES
AND OTHER PASTIMES

Gaudí had taken much interest in theatre – this was a great age for this – and he constructed several venues in private buildings, on the ground floors of houses or interior courtyards [24], for shows, theatre and even film (he was something of a pioneer of the cinema in Catalunya). For the Park Güell he created the magnificent Greek Theatre which occupies the main square, at the instance of Güell, who like Gaudí was a great admirer of classical drama. According to a news item dated March 1909: "Over the past few days Dr. Charry has been in Barcelona in order to reach an agreement with Gaudí, who plans a production of *Oedipus Rex* which will be performed in the Park Güell by several French actors, headed by Mounet Sully". Dr. Charry, the director of the Theatre de la Nature in Toulouse, was one of the best impresarios of his day, and Mounet Sully, along with Sarah Bernhardt was the best actor [24].

Gaudí had designed some iron and wood banked seating for the theatre. These were temporary and in all likelihood intended for the slope between the palm tree walk and the square, occupying part of the latter, with the stage in front of them. In this way, spectators could watch the play and at the same time see the city of Barcelona and the sea beyond – a similar arrangement to that of the temple of Apollo at Delphi. It must have been the climate of social unrest that came to a head that summer with the *Setmana Tràgica* ("Tragic Week") which put a stop to this magnificent project.

The failed attempt had a long history behind it. In 1886, the book *L'immunité par les Leucomaïnes* was published in Paris [5], and an English language version was published soon afterwards. The book was informed by the critical need in those days to combat the deadly epidemics following in Pasteur's footsteps. Pasteur, we remember, saw micro-organisms as causing disease, and perhaps also conferring immunity. According to Güell's thesis, microbe excrement could be used to make a vaccine that would destroy microbes, on the hair-of-the-dog principle that what brought the evil could also cure it.

While Güell's theory was praised in many Spanish, French, English and German journals, it eventually turned out to be wrong according to the final evaluation of the experts.

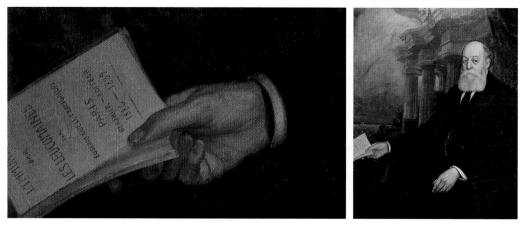

EUSEBI GÜELL PORTRAIT IN THE PARK. DESPITE HIS UTOPIAN WORKERS' COLONY, AND HIS PHILANTHROPIC TREATISE ON IMMUNOLOGY, HE OPPOSED THE WORKERS ASSOCIATIONS AND TRADE UNIONS

All the same, it was based on a deep knowledge of the subject[24], well beyond the grasp of the lay person, and Güell was justly proud of the book and the Park that was inspired by it[6]. Accordingly, in 1913, he had his portrait (now in the Park Güell Museum) painted by a young artist from Tortosa, Julio Moisés, one of the most prestigious and socially sought-after painters of his day. In the painting, Güell, by this time Count Güell, is reading none other than *L'immunité par les leucomaïnes*, seated in an aristocratic armchair before the very columns of the Greek Temple. Barcelona and what seems to be the Sagrada Família, are visible in the background. But it is worth noting that one year before Güell published his book, the leading research scientist in the field of immunology in Catalunya, Dr. Ferrán, a physician and director of the first microbiologist laboratory in Barcelona, had finally succeeded in obtaining a vaccine against cholera. This vaccine was accepted at first, but later strongly challenged, and finally given an award by the Academie de Sciences in Paris, in 1907. Ferrán's work, too, was based on Pasteur, although in more orthodox fashion. It so hap-

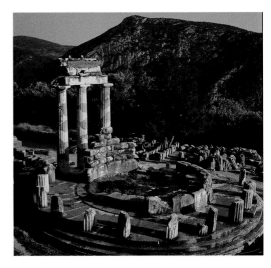

RUINS OF THE SANCTUARY OF APOLLO AT DELPHI, TAKEN AS A MODEL FOR THE PARK AND SIMILARLY ON A MOUNTAIN NEAR THE SEA, WITH TEMPLE, THEATRE ETC.

pened that Ferrán was a mason, and both he and Eusebi Güell had philanthropy as their principal virtue.

Güell and Gaudí did not just want to present Sophocles' impressive tragedy *Oedipus Rex* because of its brilliance and grandeur, but because the hero of the tragedy fights an epidemic, and presenting it in the open air would be fulfilling one of the great requisites of hygiene, in an age in which epidemics had their breeding ground in the closed-in areas in the towns. Oedipus does not realise until the end that he himself is the virus of the infectious disease that he is trying to combat, and for that reason tears out his eyes to save the city when he discovers the truth. The carrier of the evil becomes its healing or salvation, the thesis put forward in Güell's study [5].

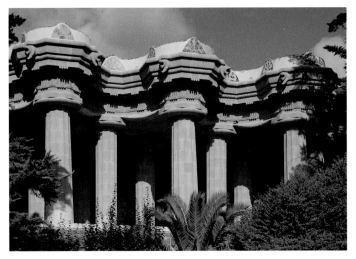

DORIC COLONNADE

The sanctuary of Apollo

The Park is laid out in the image and likeness of the Sanctuary of Apollo at Delphi, as explained in J.J. Lahuerta's masterly exposition [17]. Observe that we have to do here with an enclosure, facing the sea; with the Sacred Way – the steps – leading up to it ; halfway up, the temple of a god, one who kills the snake Python, protector of the waters, and takes its place [12]; the seer who drinks from the Castalian spring (here Sarva [2]) and then speaks oracles, seated on the tripod, inspired by soma (here the *amanita muscaria*); or has the *omphalos* or navel to make connection with the subterranean world – the cistern – and with the supernatural. Delphi stands for the Greek homeland, as the Park symbolises the Catalan people. And Apollo is the sun god, the heavenly body that sends the epidemics with its arrows, which are also arrows of healing – the evil and the good that come from the light and the heat. Moreover, Apollo has a theatre above the sanctuary at Delphi as in the Park, where heroes can act out fables and myths, in dramatic form, explaining the forces of destiny and the deep levels of the soul of Man.

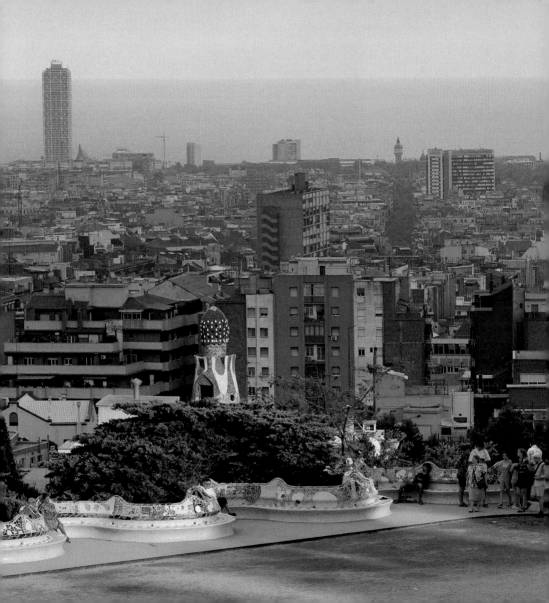

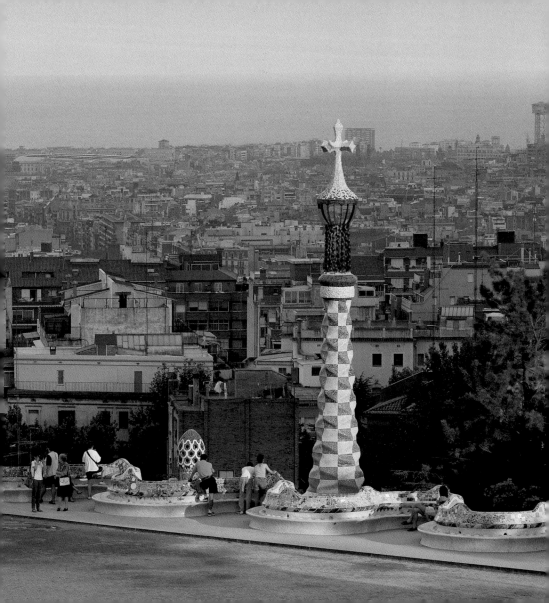

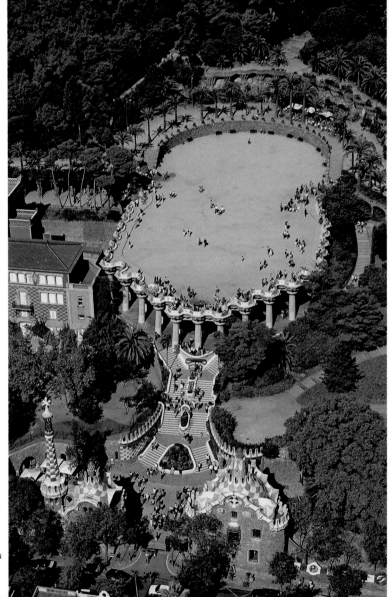

SHORTLY AFTER
PHILANTHROPIST EUSEBI GÜELL
DIED IN 1918, PARK GÜELL
BECAME A PUBLIC PARK. THE
GREATEST RISK WAS THAT IT
MIGHT DETERIORATE; THE
GREATEST ASSET, ITS INVITATION
TO TOGETHERNESS

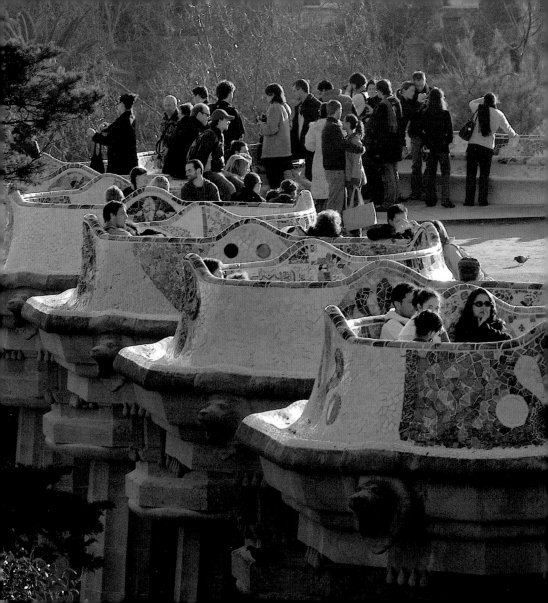

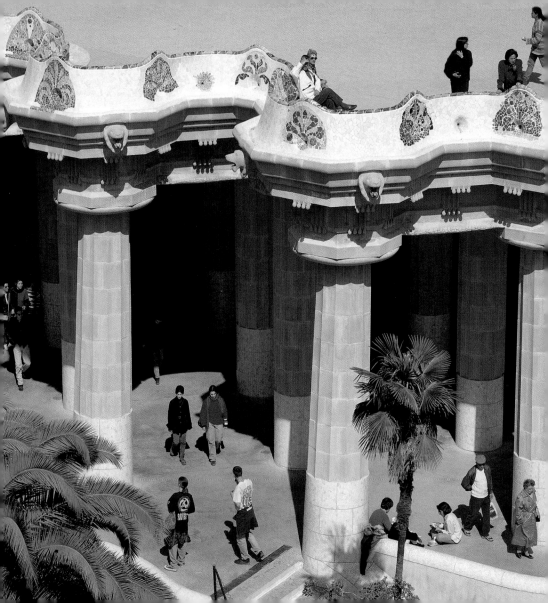

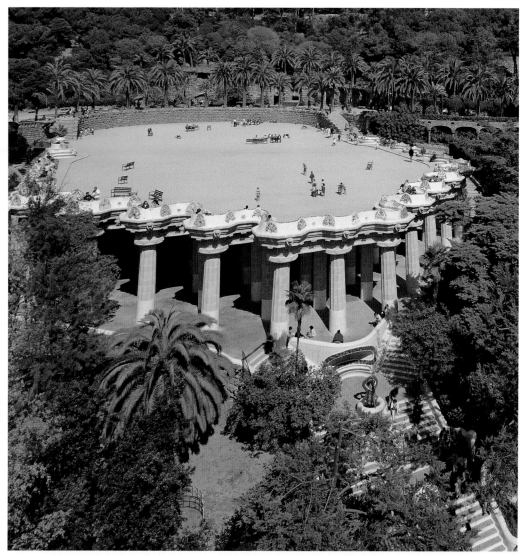

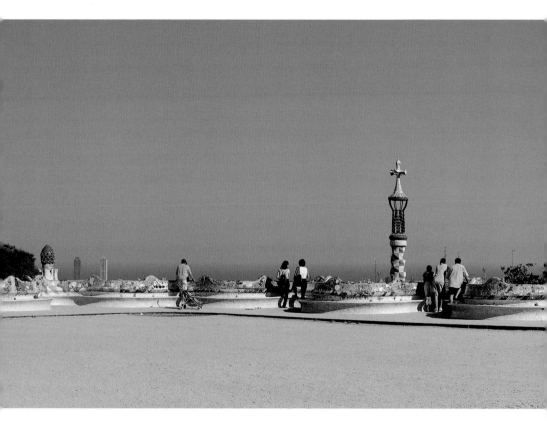

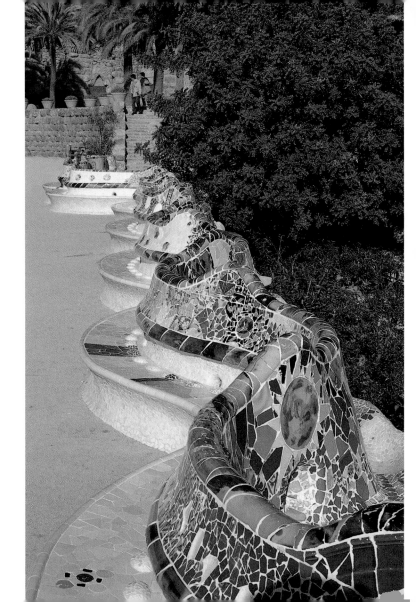

UNDULATING BENCH

PART OF JUJOL'S DINNER
SERVICE

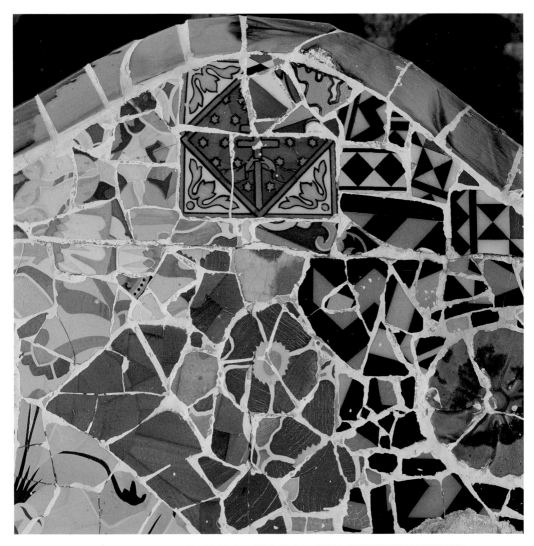

TYPICAL OF TRENCADÍS IS THE IMPRESSION OF COHERENT DESIGN CONTRASTING ABRUPT CHANGE OF PATTERN OR INCOHERENCE

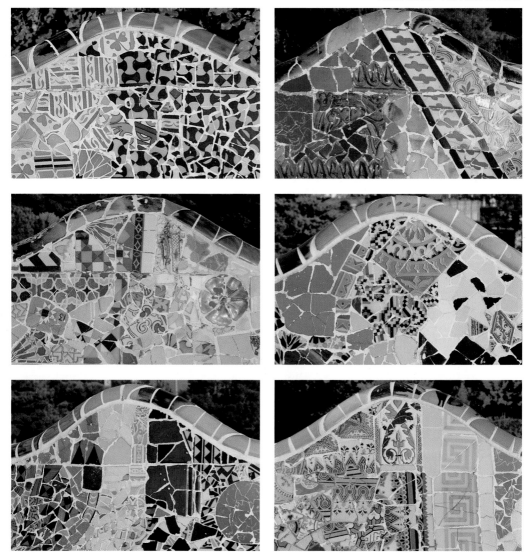

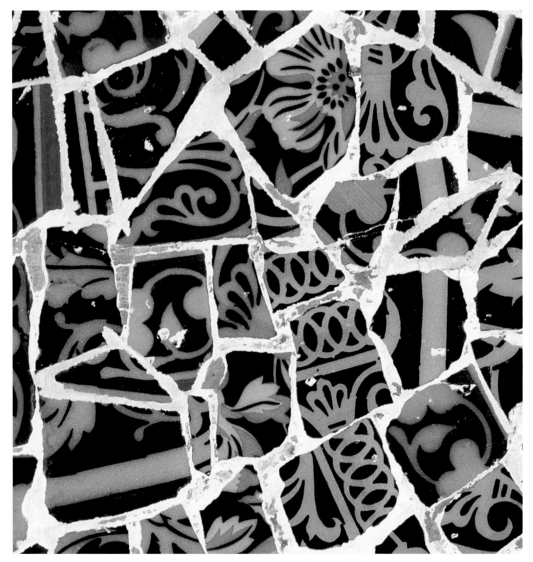

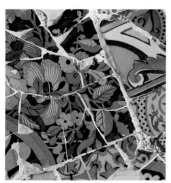
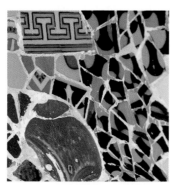

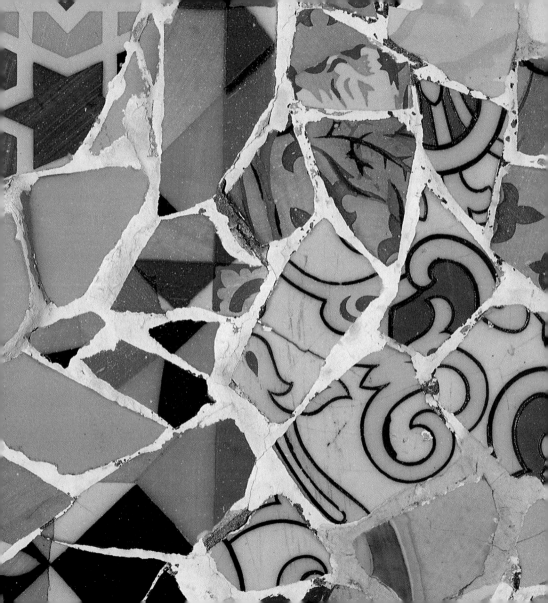

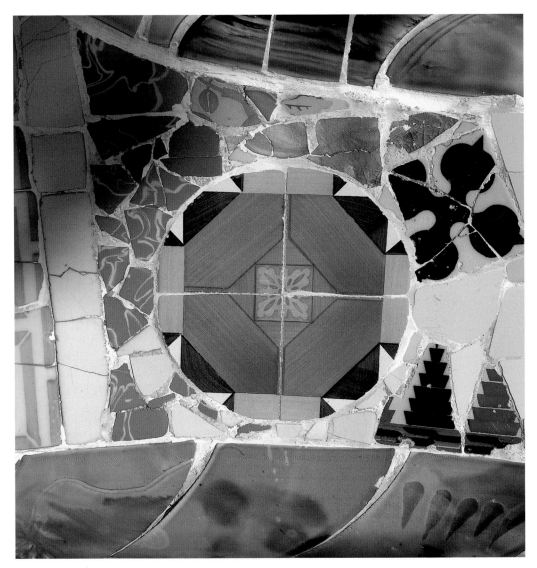

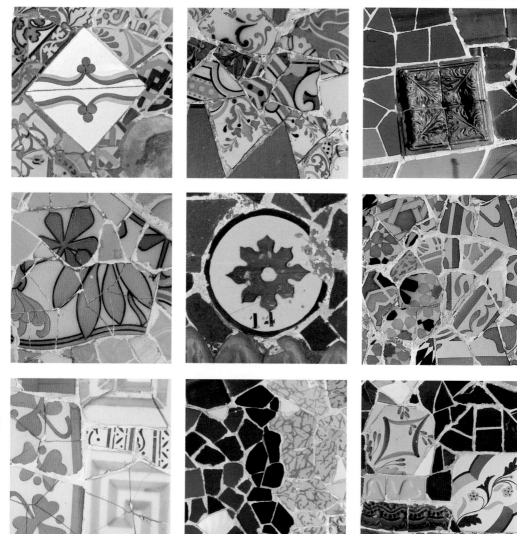

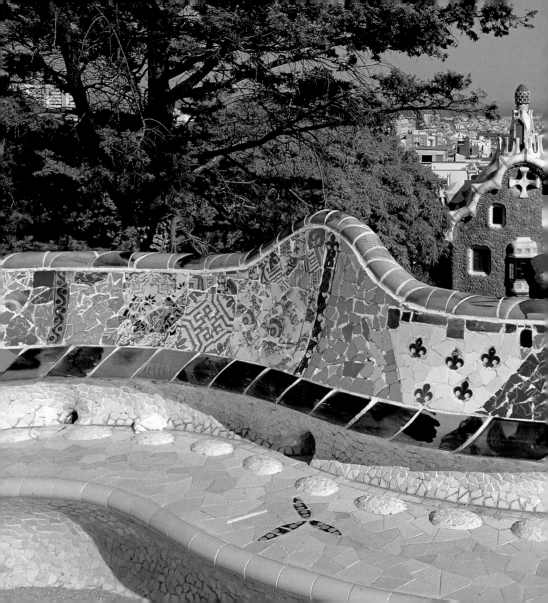

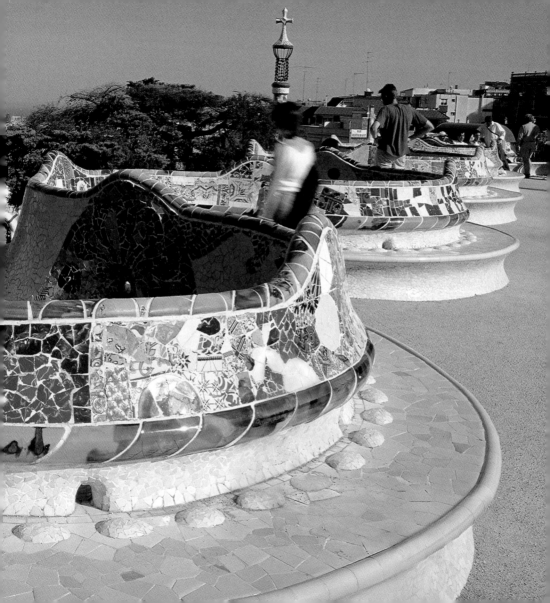

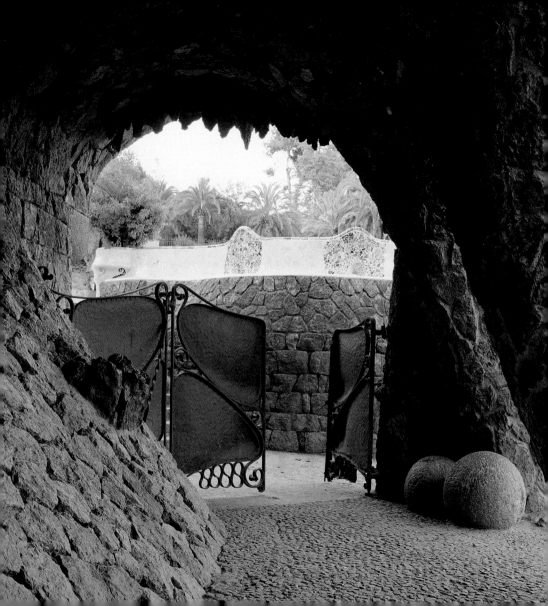

SERPENTINE PATHS

Not just the bench is sinuous. All the paths in the Park – fully three kilometres of them – are snake-like too, as are the viaducts and porticoes. To make them it proved necessary to remove several rocky areas at great cost in money and effort, employing 14 builders and their assistants. Gaudí declared: The idea is to increase and ease communication between the different places in the Park using only materials taken from the land itself [3].

On the left of the Theatre square there is easy access to three successive porticoes. In the first, which runs behind the Güell House (now a state school) all the pillars are different, and on one of them especially is a figure known as la Lavandera (the washerwoman) who at one time held a stick in her hand, so the story goes, to beat the washing. The feast day of the washerwomen is, like that of the innkeepers and victuallers, Saint Martha's day, on the 29th of July. But, given Gaudí's particular world view and the penchant he had in mixing the Catholic with the esoteric, it is likely that this figure is the Hermana Masona (Sister Mason). Granted, some tendencies within the Order excluded women, others admitted them as "Accepted Masons" [25]. In the photographs and drawings from the years around the turn of the century, lodges can be seen with women Masons of the second or third degree, wearing the same garb as the figure in the portico: the hair gathered, a broad ribbon on the breast from which hangs a jewel, the sleeves rolled up to work, the apron with a rounded hem and, in their hands the steel plasterer's trowel with handle [32]. In the ceremony of admission of the Perfect Woman Mason, which is what is portrayed here, the inductor acts out the temptation of Eve in the Garden of Eden, persuading her to bite the apple of the Tree of Knowledge of Good and Evil. This is why she carries a basket of apples (stones) on her head, and why, after

"IN THE PARK GÜELL WE GO INTO THE GROTTOS THROUGH OX-LIVER-SHAPED GATES." SALVADOR DALÍ, 1933

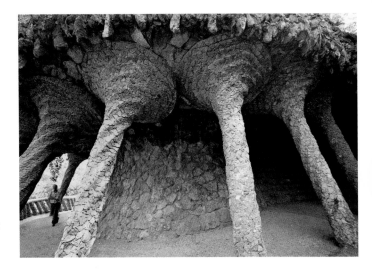

PANORAMIC VIEW OF THE PORTICO

LA LAVANDERA PORTICO, SHAPED LIKE
A LONG CURLING WAVE; THE SORT
PERFECT FOR SURFERS, BUT IN MASONIC
IMAGERY SUGGESTING THE FAMOUS
BIBLICAL CROSSING OF THE RED SEA

trying one of them the fury of God makes the Earth tremble and stones rain down all around her. That is the story told by this expressive work. This version, then, is very different from the Catholic equivalent, as happens with other stories from the Bible, but Güell and his associates knew how to harmonise them.

The Portico itself is a structure of rare originality. The outside columns are inclined inwards to withstand the stresses generated by the sloping land, forming a wide stone arch, curling surprisingly over the walkway. Some have taken this to be a wave, and indeed it is. But it is the type of wave that shielded and protected the Children of Israel, forming a tunnel when they were pursued by Pharaoh's army, in the famous crossing of the Red Sea [25/32]. This miracle is represented, ritualistically, in precisely the ceremony of admission of the Perfect Woman Mason, with the men's swords and the women's wands making the tunnel, as the extended hand of Moses suggests in the Bible [32]. This is one more example, a very plain one, of the very profound relationship between symbolism and architecture in Gaudí's work.

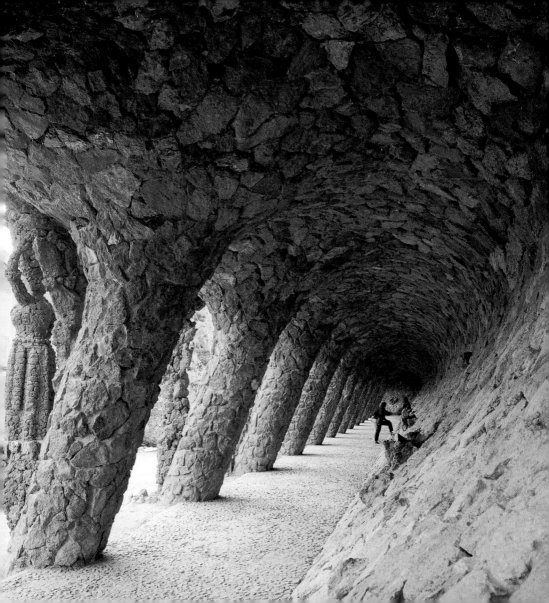

At the end of this Portico the second one begins without any break, formed by a semicircle of columns, with a spiral pattern inscribed on them in the direction of natural growth (clockwise) as in some trees. They look like fine wine glasses, and that is exactly what they are, for the toast proper to the Feast of Friendship [25]. This is celebrated rowdily at the summer and winter solstices, which are important feast days for the order, as already mentioned in connection with the purchase of Can Muntaner.

Beneath the Portico of the Toast is the third Portico, a clear symbolic reference to the fellowship among *brethren*, and the support the strongest should give to the rest. This Portico reminds one of the *castells*, that typically Catalan feat of strength and balance, where teams build human pyramids several tiers high [10]. The three Porticoes are naturalistic in style, in the Gaudian manner of obeying the laws of nature and imitating the natural, – like the wave – or even the artificial in the case of the wine glasses.

The same Porticoes lead back to the main Avenue, which is the widest of them all, measuring some ten metres across. The old Roman road followed the same route from old Barcino (Roman Barcelona) through Sant Cugat, on the landward side of the mountain, to the place called Sant Sever, in memory of the bishop who fled this way during one of the persecutions of the Christians [4]. In this part opposite the square, the avenue is lined with real and artificial palms. In the wall there are iron gates and a refreshments stall barring the way to caves and galleries inside the mountain which, it was commonly said at the time, had been used by stone workers in search of stone. This would seem to be a veiled allusion to the medieval masons, and it was based on this craft and its guild that freemasonry was created at the beginning of the 18th century. Gaudí wanted to put artefacts that played with water and light in these galleries, and probably would have linked this with the primitive altar that has survived in a corner, like the nymphaea of old, where the classical was combined with the archaic.

SECOND PORTICO FEATURING SPIRAL
CHAMPAGNE-GLASS COLUMNS

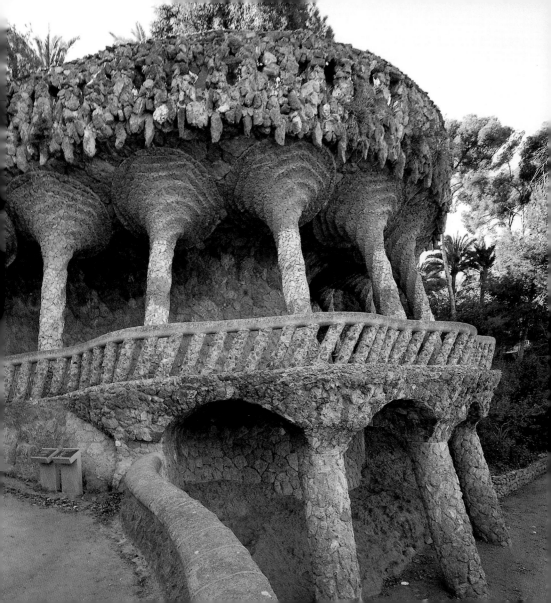

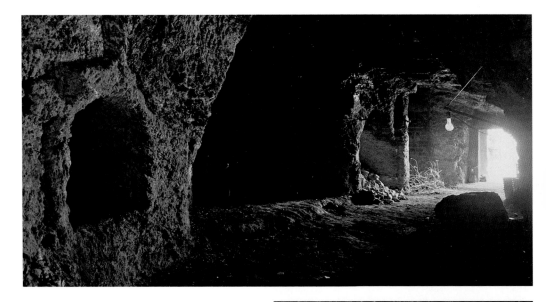

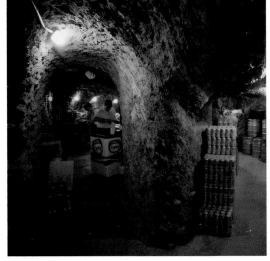

NICHE IN THE CAVE

INTERIOR OF THE CAVES DUG OUT
BY STONEMASONS

STONE PALMS AT TOP END OF
THEATRE SQUARE. CLOSED DOOR
TO THE ARTIFICIAL CAVES

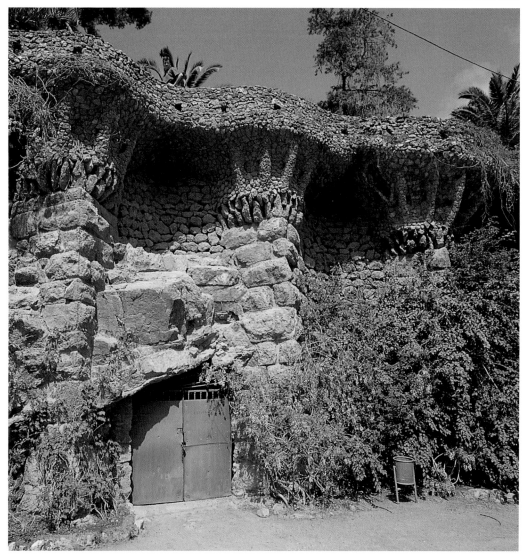

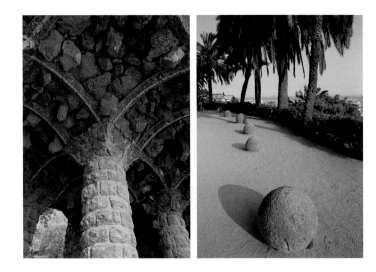

ROOFS OF ROUGH STONE, ABOVE
THE DRESSED STONE OF THE
COLUMNS IN THE MIDDLE VIADUCT

GREAT BEADS IN THE GIANT
ROSARY

LOWER VIADUCT

In this same avenue there is a series of spherical stones like the beads in a giant rosary: some are arranged in a row, while others are scattered throughout the Park, and still others have vanished. The common Christian rosary consists of five groups of ten beads (for the same number of Hail Marys) with five others for the Lord's Prayer, forming a necklace, from which hang 5 further beads, with a cross at the end. The full rosary (like the one in the Park) is used by monks and nuns, and is the equivalent of praying the simple rosary three times, with a total of 150 of the first prayer, 15 of the second and 5 of the third. Each round of prayer represents a mystery, of joy, pain or glory, relating to events in the life of Jesus and the Virgin. At one time it was the custom to pray the rosary every day as a family, and on holy days and in October, the month especially chosen for this devotion, the three groups of mysteries were prayed. Praying the rosary began in the 13th century, and the Dominicans gave it the meaning of devotion to the Virgin of the Rose, in which every bead represented a rose bloom. The rosary is ultimately of Hindu origin and is also a ritual in Islam, and of the religions of the Far East, Tibet,

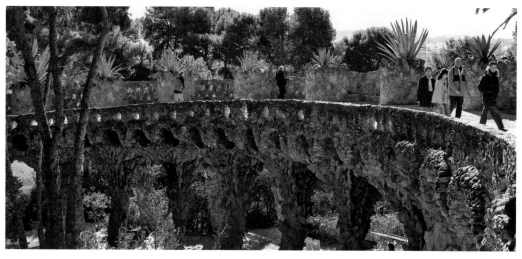

etc. A devout practice, it is redolent with history, cyclic symbolism and rhythm. It is known that Gaudí used to walk around it, and would stop at every new spherical stone or "bead"; what is not known is exactly what he was thinking.

This avenue takes you past the Gaudí House and Museum, and then turning to the right, you arrive at the first raised walk or curved viaduct, known as the Lower Viaduct. The mathematics for this, and the other two higher up, was calculated by another of Gaudí's great collaborators, the Reus-born architect Joan Rubió, and has 2 or 3 times 14 columns. The raised walk is lined here by irregularly positioned rustic benches and primitive stone jars, with flower pots containing American aloes (this time, the real plants). If this is notable in itself, all the more so is also the competition below it between slanting pines and two series of stone palm trees, also leaning one against the other, with the fronds overhead becoming stone vaulting. Equally curious are the trunks of the palm trees, whose stones seem to want to escape from their confinement and jut out like heads of tortoises, dragons, lambs

or whatever the spectator might see in them. Both this viaduct and the others are supported by cylindrical brick pillars, clad in stone obtained on the site, although there are also columns formed of undressed stone. Nature and artifice blend, and in the dusk the confusion is complete.

The main avenue takes you to the gate leading onto the Carmel road, the latter used by most visitors travelling to the Park by public or private transport. The name Carmel (Mount Carmel) reminds one of great mystics like Saint Theresa of Avila and Saint John of the Cross, and it is possible that the creators of the Park had this and other ways of devotion such as Montserrat in mind [1].

Near this entrance the path branches off to the Middle Viaduct and, immediately afterward, to the Upper one, forming two curves that curve round through almost 360 degrees. The Middle Viaduct is another marvel, similar to the Lower Viaduct but more complex. Half way round is a row of vertical columns, with a further two similar rows on either side, leaning inwards upon them as if gravitating, forming two separate aisles. The roof so formed is flattened, forming squares.

The Upper Viaduct also has three series of 14 columns, but these are staggered, and the "branches" that support the stone roofs seem to have broken under the excessive weight. The columns are of three types: the most elaborate and finished form the shaft; others are of rougher stone that jut out from them; and the third type have capitals seemingly made of crumbling clay or stone. This last-mentioned effect is one of the most interesting in the Park, and once again is evocative of the Latin poet Ovid and his cosmology, with its confusion of the hard and soft. It is reminiscent, too, of Baroque art [2]. At the foot of certain columns there are stone seats with backrests and corbels on both sides, as if this were a place of meditation and work, a place for thinking, reading, writing. The jars which line the path, twenty-one in number, are similar to those lining the Lower Viaduct, although everything here is more expressive.

THE THREE VIADUCTS, SEEN FROM THE AIR

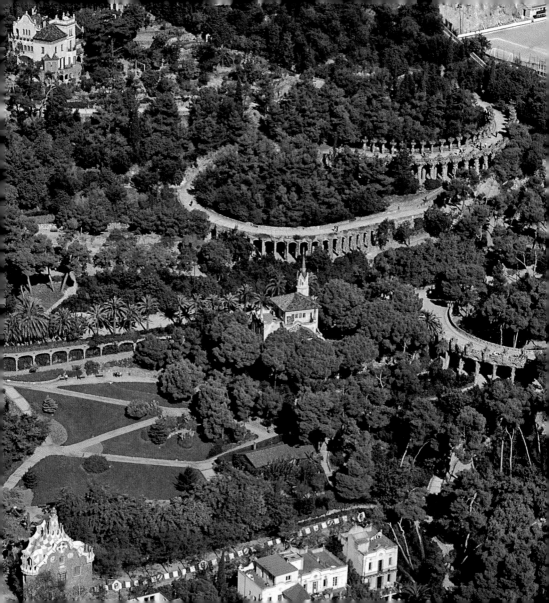

In front of the Trías house a path leads off to the left side of the Park. This part was formerly known as the Muntanya Pelada (Bare Mountain), where countless al fresco lunches and popular picnics were enjoyed in days gone by, while mount Carmel, of which it formed a part, was a wood at that time. This state of affairs was reversed, however, with the devastation of the Spanish Civil War (1936-1939), when the Carmel became a wasteland[2]. On Muntanya Pelada there had only been a handful of locust trees, like the one that was preserved on Gaudí's instructions in the Middle Viaduct, and more were planted. The same was done with the pines, to which were added acacias, palms, cedars, eucalyptus trees, cypresses, planes, elms, plum trees, etc., as well as shrubs and smaller plants like rosemary, broom, thyme, aloes, artemisia, evonymus, daturas, hibiscus, laurels, rhododendrons, ivy, bougainvillea and a number of others[12]. Many of these have a symbolic value; others are medicinal, others form a protective fence; still others are ornamental. However, the criteria by which Gaudí selected these plants is not well understood, guided as he surely was by something more than just gardening. And of course, over the years more species of trees and plants have been planted, and perhaps others have disappeared.

C. Kent and D. Prindle are rigorously striving for an admirable synthesis – of architectural styles, religious devotion, national pride, technological advance, and utopian ideals, within the natural beauty of the Park.

GAUDÍ SAID OF THE PARK: "THE IDEA IS
TO INCREASE AND EASE COMMUNICATION
BETWEEN THE DIFFERENT PLACES
IN THE PARK USING ONLY MATERIALS TAKEN
FROM THE LAND ITSELF"

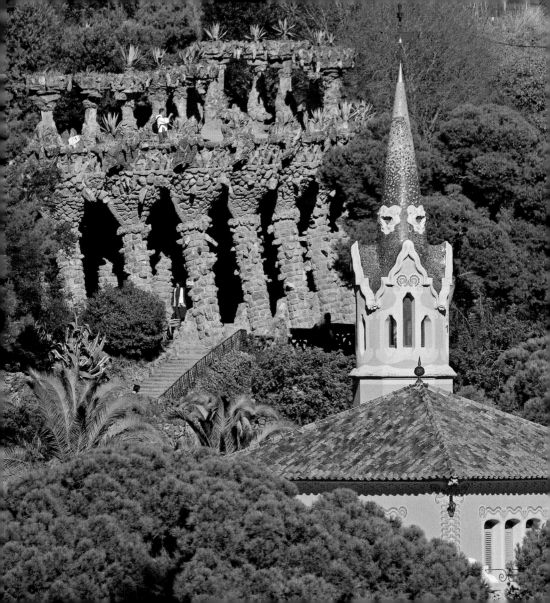

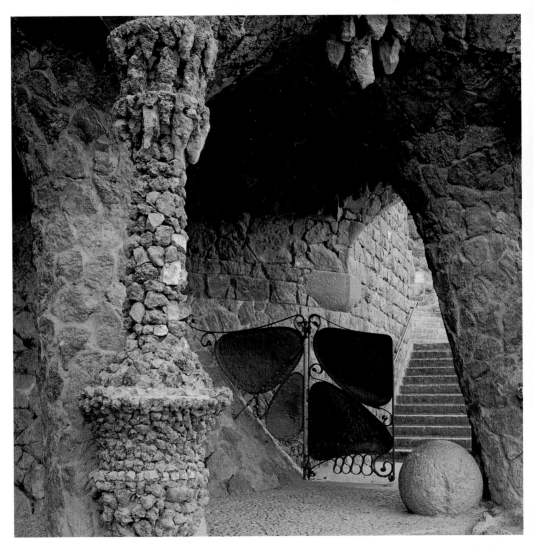

PORCH OF THE WASHERWOMAN AND THE VENERABLE SISTER MASON WITH BASKET OF APPLES, POPULARLY KNOWN AS «THE WASHERWOMAN»

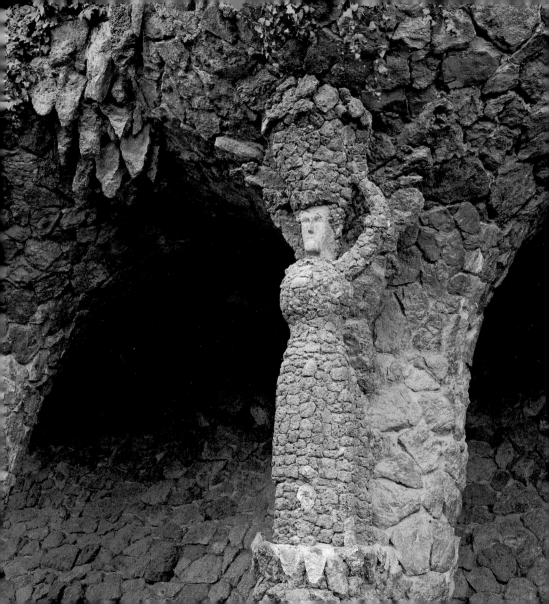

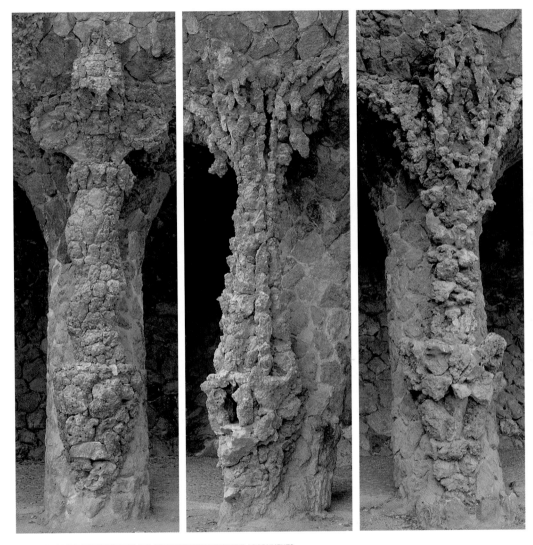

PORCH OF THE WASHERWOMAN AND COLUMNS WITH DIFFERENT ADORNMENTS

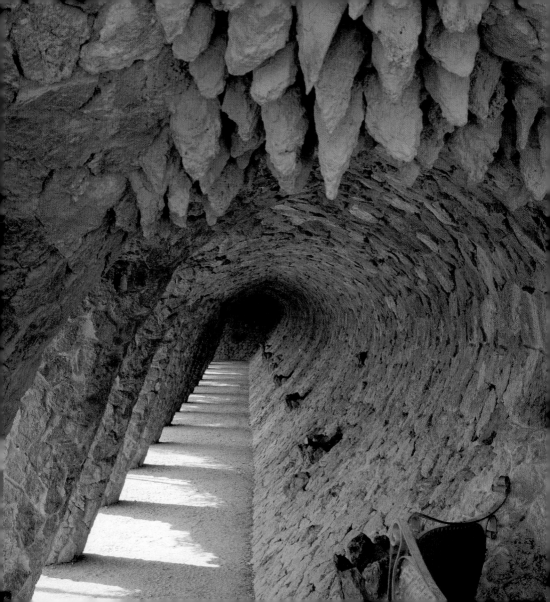

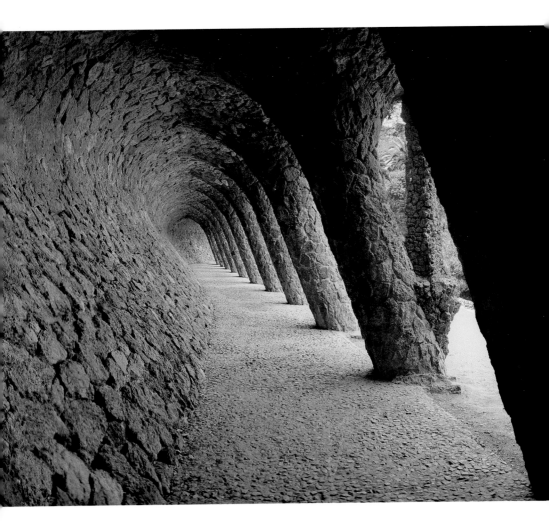

PANORAMIC VIEW OF THE PORTICO

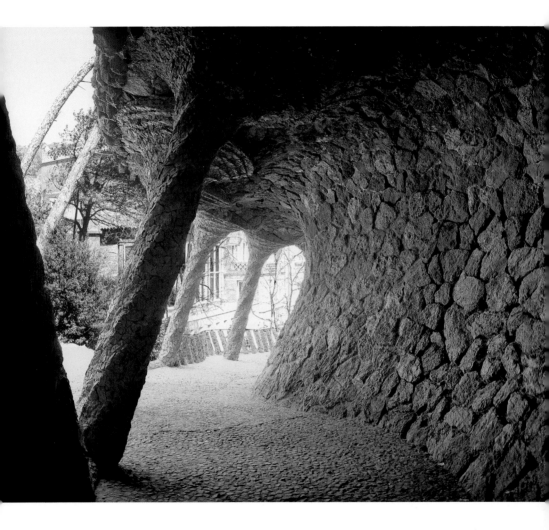

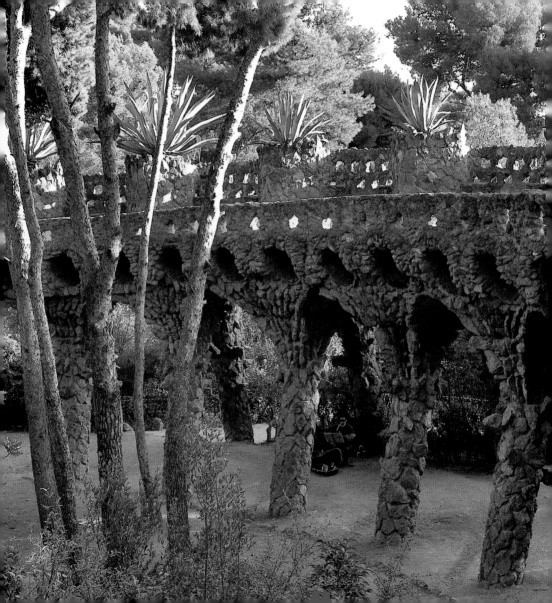

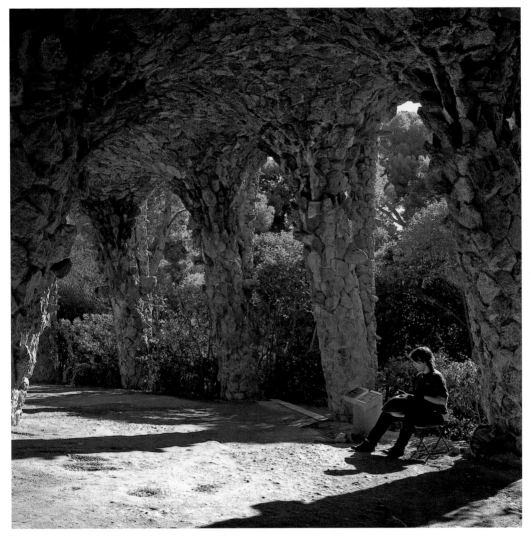

LOWER VIADUCT WITH PALM TREES FORMS, CLAD WITH STONE FROM THE SITE

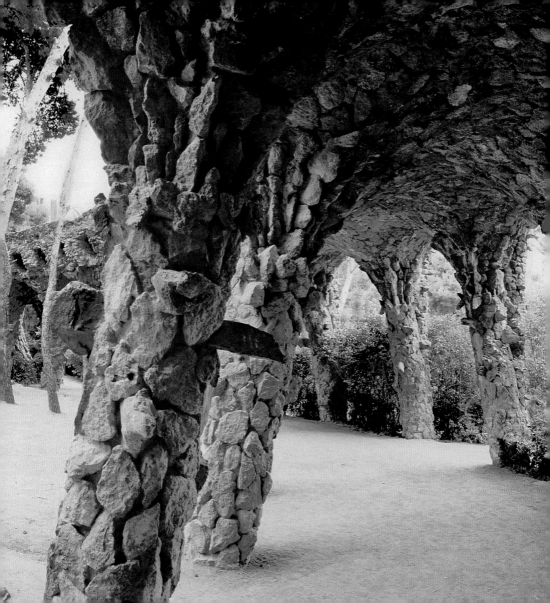

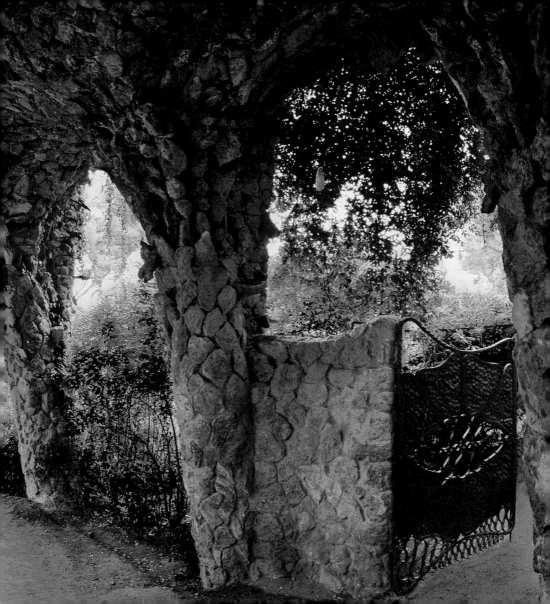

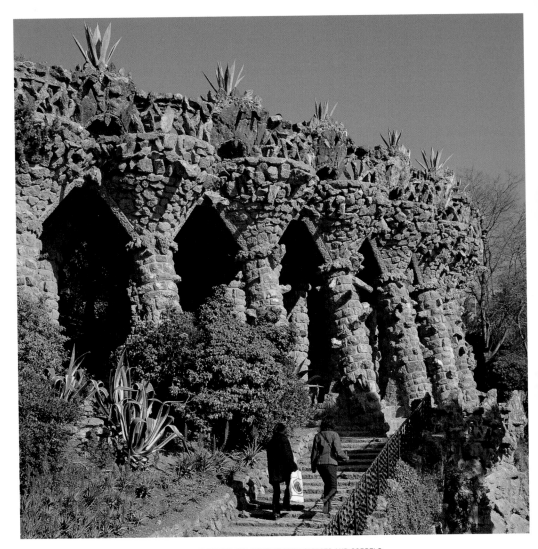

UPPER VIADUCT: VIEW OF COLUMNS WITH JUTTING STONES AND SEATS WITH BACKRESTS AND CORBELS

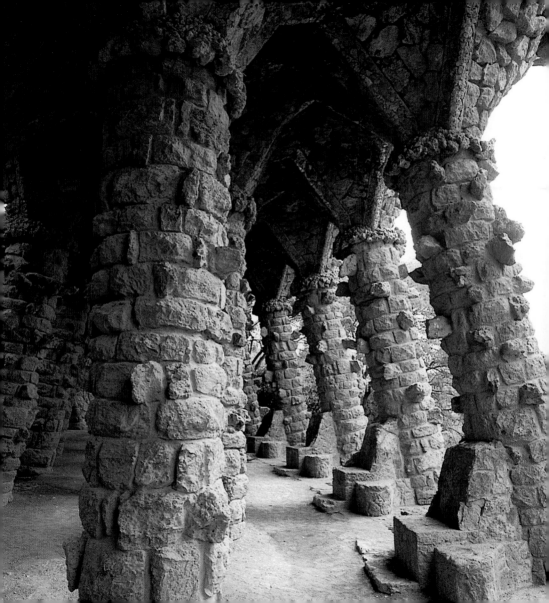

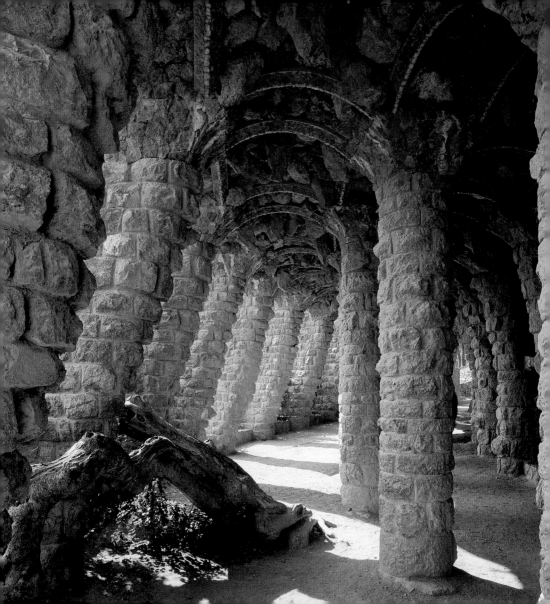

CENTRAL VIADUCT WITH THE CAROB TREE THAT GAUDÍ WANTED TO PRESERVE AND POTS WITH AGAVES

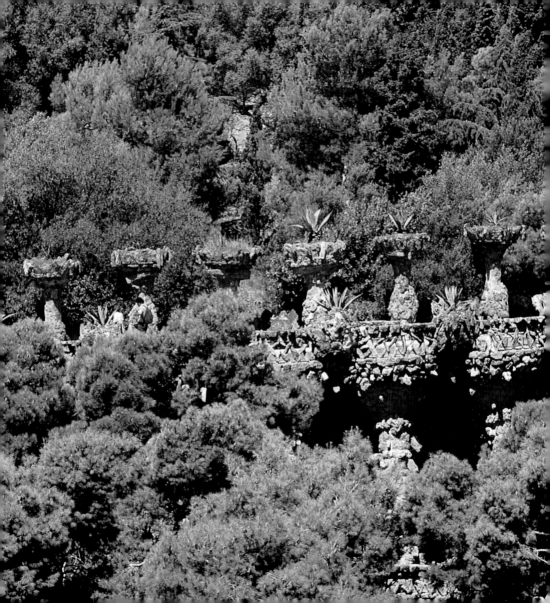

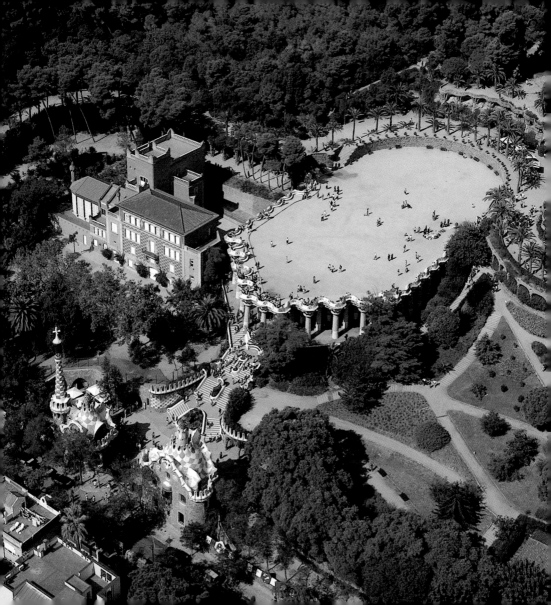

THE RIGHT ANGLE

The Güell house

Gaudí was commissioned to carry out work on the Casa Muntaner (the original house on the estate) to adapt it to the needs of Güell and his family: he added a porch, an archway leading to the chapel, and a conservatory. Neoclassical tapestries by El Vigatà were hung in the drawing room, complete with the figures of Apollo, Mercury and other Greek gods. The Güell family house immediately became the most outstanding focus of city life, and welcomed all classes and walks of life from members of the Spanish royal family to skilled artisans and workmen.

Count Güell died at his home on the 8th of July 1918. Curiously, the chapel of rest was installed in an eight-sided room, a shape often taken by christening fonts (with the suggestion of resurrection) and in general the room was prepared according to Güell's instructions. One piece of furniture portrayed Joshua raising his hand to stop the sun and thus win the battle, as in the Biblical story. Joshua was positioned so that he was looking at the sun-shaped ceiling light, radiating its golden rays outward to the walls, on which were the signs of the zodiac. This was a perfect synthesis of the Bible, Greece, and astrology, in turn linked to the panels of the sun and the moon in the room. The inspiration for this came from Joan Maragall's *Càntic espiritual*, a poem in which Joshua's feat is mentioned, and where it is urged that death should be "a greater birth". Maragall was Güell's friend.

And there is more. On the following morning, the body was taken to the Palau Güell (the Güell mansion) just off La Rambla, to lie in state in the main drawing room; later a service was held in the nearby church of Santa Mónica, filled to overflowing with dignitaries and people from all walks of life. And as the final act, the funeral cortège left from none

UPPER PART OF THE HOUSE
WITH MOUNDS OF STONES, THE
SIGN OF HERMES - MERCURY

THE GÜELL RESIDENCE,
FORMERLY CAN MUNTANER

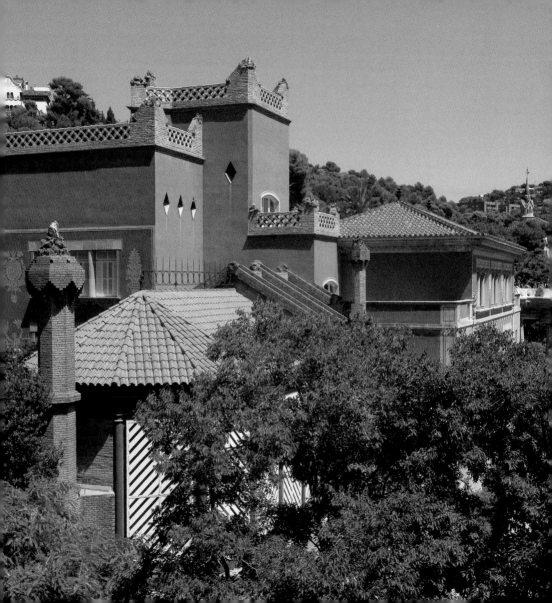

PARABOLIC ARCH AND
ORNAMENT WITH JESUS
ANAGRAM

other than the Pórticos de Xifré opposite the house of the *indiano masón* (mason from the Indies)[24] who had died there 52 years earlier.

The Trias house

The lawyer Martín Trias Domènech commissioned architect J. Batllevell to design his house, in modernist style (1906), on a double plot on higher ground in the Park, recommended by Gaudí for its views and the steep escarpment which would allow entrances to the woods from below and from the terrace at the rear, which constituted another Gaudian innovation[3]. Although these were plots C and D, the house was listed as number 32, which figures when added together give 5; furthermore, 32 is the number of winds in the wind rose, and esoterically speaking, the number of the knights of Saint Andrew, Paracelsus' figures of the future, the 32 steps of the highest flight of stairs leading up to the *azotea* (roof terrace) in the La Pedrera building, etc. Even more importantly, the three houses, the Güells', Gaudí's and his own, formed a set square in which the line from the Güells' house to the Trias' house was the hypotenuse, such that the venerable Gaudí had to be the right angle, not entirely by accident. The triangle as a Masonic figure symbolises the venerable. And indeed, the surname Trias, not to mention the muses, the triple goddess or the Trinity, the third, all suggest that this man did not move into the Park as just another property owner. There were occult aspects which details such as these reveal.

ACCORDING TO GAUDÍ "THINGS HAVE TO BE CLEARLY ASYMMETRICAL: BUILDINGS, FLIGHTS OF STEPS, UNEVEN VOLUMES, ETC. SYMMETRY IS FOR LEVEL GROUND"

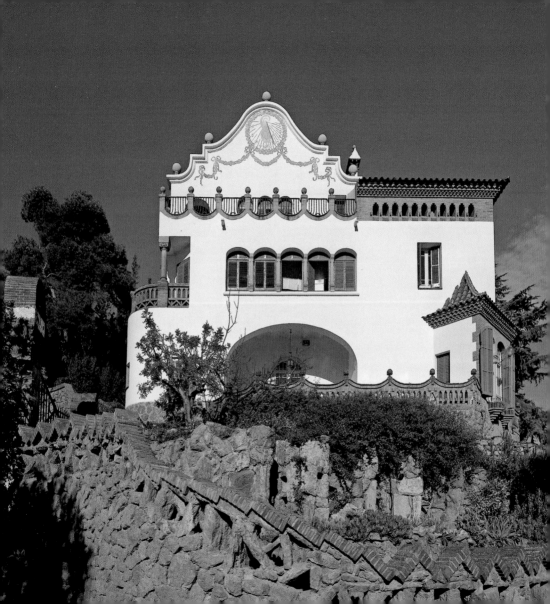

MARIAN DECORATION OF THE VESTIBULE
OF THE GAUDÍ MUSEUM

PINK HOUSE WHERE GAUDÍ LIVED
FOR 20 YEARS, NOW THE GAUDÍ MUSEUM

The Gaudí house

What is now the House-Museum Gaudí was formerly Gaudí's house in the Park, and was originally built (1903-1904) as a show house for prospective customers to view. As it apparently still had not been sold in early 1906, Gaudí bought it. It is a typical modernist detached house, next to the main avenue, built by Francesc Berenguer, Gaudí's assistant, on steep land, with a terraced garden. It has a basement and cellar with a meat safe, and three floors, a tower in three parts, with spire, cross and wind rose. The second floor features a fine iron balcony, as well as very Gaudian chimneys, which remind one of morel mushrooms. Several different features, the pergola for instance, show Gaudí's hand in the work.

The house is named *Torre Rosa*, very aptly so because Gaudí was from Reus, where there is a rose in the city's coat of arms, and where many women were called Rosa, including Gaudí's sister and niece. There is also the *Verge del Roser* and *del Rosari*, to whom Gaudí was especially devoted. Just as decisive was the fact that besides being Catholic, Gaudí had other, less orthodox beliefs, not least Rosicrucianism, Gnosticism and alchemy, as his initiator in these subjects, Eduardo Rojo, has shown.

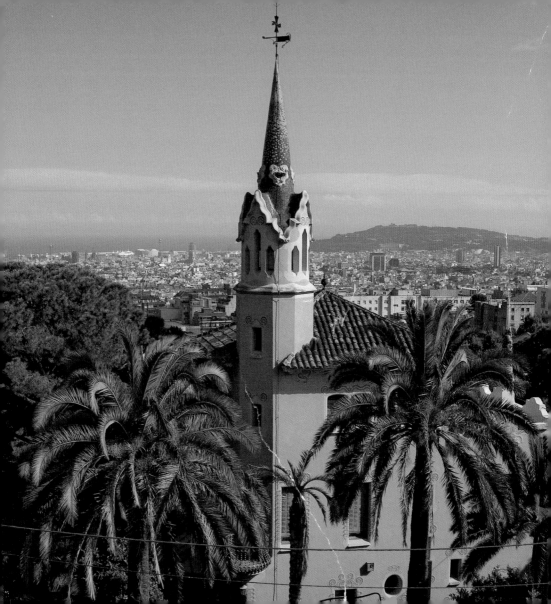

Gaudí moved into the house in 1906 with his father, who died soon afterwards, his niece Rosita and Vicenta the maid, plus assistance from the Carmelite nuns of Sant Josep. Vivacious, thirty-year old Rosita was a sensual and passionate young woman, who welcomed visitors with bouquets of thyme and flowers, but – like Ophelia – she felt abandoned and eventually became alcoholic. Gaudí was not an easy man to get on with and not at all given to familiarity. Rosita told a woman friend of hers: "Don't even think of marrying a genius!". She died during an attack of *delirium tremens* in January 1912. Ever more solitary, Gaudí had an occasional friend or relative spend the night at the house. Until, towards the end of 1925, he moved to the Sagrada Familia, and died in an accident – under the wheels of a tram – on 10th of June 1926. So ended one of the most intensely creative lives in history.

The house in the Park was bought by the Friends of Gaudí and was inaugurated in 1963 as the House-Museum Gaudí [16], a fascinating museum, with the architect's furniture, models, drawings and personal memorabilia, as well as those of his collaborators, friends and artists who worked with him.

THE GAUDÍ MUSEUM, ORIGINALLY
A SHOWROOM CHALET DESIGNED
BY FRANCESC BERENGUER

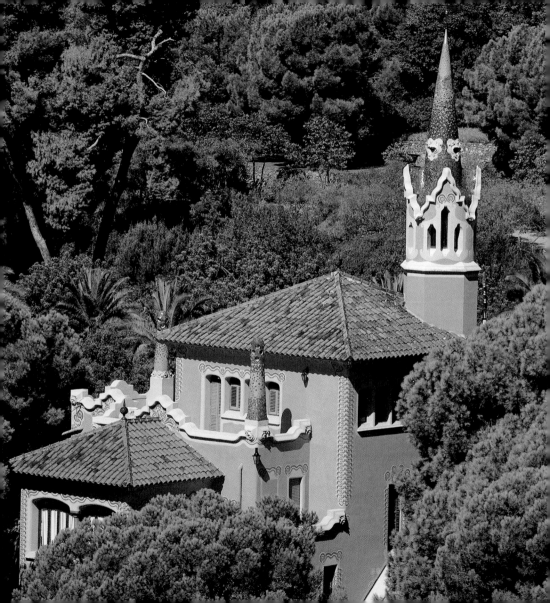

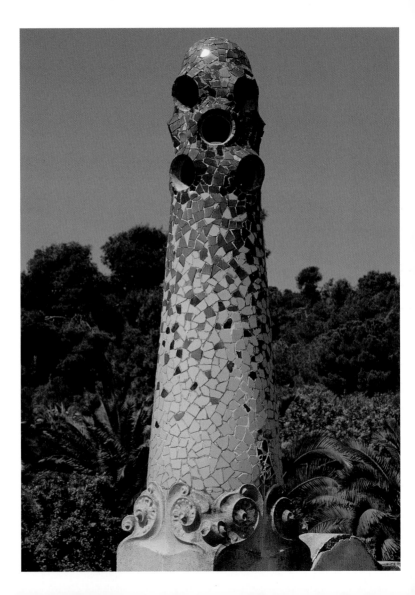

CHIMNEY, MODELLED
ON HONEYCOMB MOREL
MUSHROOMS SUGGESTING
THE INDUSTRIOUS BEE

DECORATION WITH
MODERNIST MOTIFS

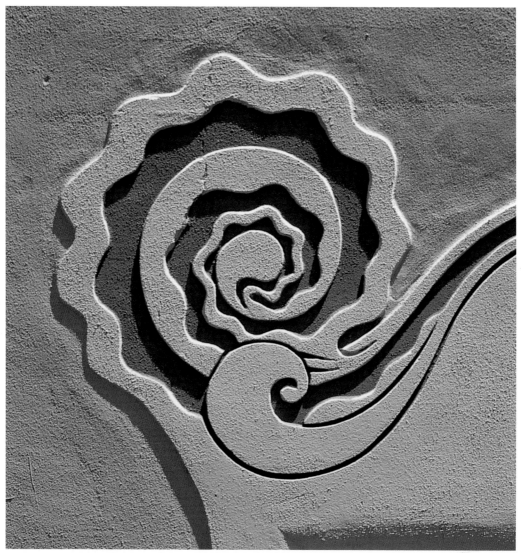

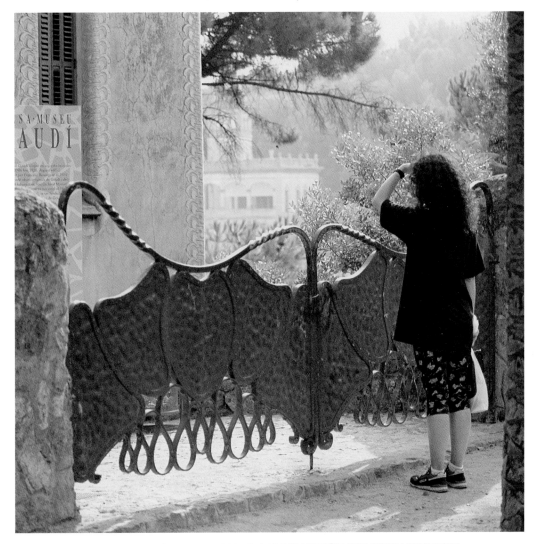

GRILLE AT THE ENTRANCE OF THE GAUDÍ MUSEUM AND INSIDE: VESTIBULE, BUST OF GAUDÍ BY JOAN MATAMALA AND FOOD SAFE

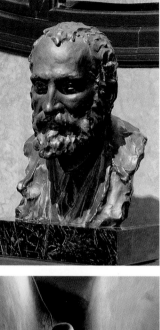

LANTERN BY FRANCESC
BERENGUER

GAUDÍ'S BEDROOM

DRAWING ROOM ON
THE GROUND FLOOR, WITH
THE FAMOUS CHAIRS AND
BENCHES FROM THE CASA
BATLLÓ

ORIGINAL FURNISHINGS FROM THE
CASA CALVET AND CASA BATLLÓ

THE CLOSED CHAPEL

On the left side of the Park is the hill known as the Turó de les Menes (Iron Ore Hill), so named for the deposits of iron that it contains. At the foot of the Turó a cave was discovered with fossilised bones of rhinoceroses and other animals – studied by the geologist priests Font i Sagué and Almera – thus conferring mythical origins on the Park [17], ideal for Güell and Gaudí, who were seekers of ancestral roots, typical enough in the 19th century. And next to the cave, narrow tunnels were found which at the time were thought to have been made by cavemen, but which were probably excavated by miners at a later date. They are still there, though they have been shut up for decades.

For the top of this hill, Gaudí had originally designed a great Christian cross [11], but in the plan made in 1903 he already shows the layout of a little 6-lobed building, and alongside it the word *Capelya*. This is an unorthodox way of writing the word *capella* (chapel), and no doubt shows influence from the proposed Catalan spelling reform put forward by the young Reus-born linguist Miquel Ventura [28]. Gaudí, at any rate, wrote the word in his own way, to refer to an archaic chapel. It is relevant to note that the Aladern and Ventura group wanted to hold a Druid festival, in a natural setting, close to a megalithic site, with no artefacts but the natural, inspired by the vitalism then in vogue.

CALVARY IN SHAPE OF A TALAYOT

TALAIOT AT TORELLÓ, ON THE ISLAND OF MENORCA

TURÓ DE LA MENAS OR THE HILL
OF THE THREE CROSSES

PLAN OF LOBE-SHAPED HERMETIC CHAPEL

DRAWING OF A CROSS NOT SUBSEQUENTLY
MADE, WITH THE OBJECTS USED
IN THE SCOURGING OF CHRIST

OLD PHOTOGRAPH, WHERE THE SHAPE
OF THE ARROW IS MORE ACCENTUATED
THAN IT IS NOW

The *Capelya* is a talayot, or watchtower typical of the Balearic Islands, military in function (at that time still thought to be Celtic), and is thus in keeping with the outer wall, crenelations and security of the Park. It was also thought that the talaiots were primitive sanctuaries, and it was for that reason that Gaudí called the structure a *Capelya*, a shrine tended by Druid priests then very fashionable. But the most ingenious feature of this chapel is that it really is "hermetic", in that it lacks doors and windows, and the hermetic doctrine, or doctrine of Hermes, is secret and closed.

The lobed shape of the chapel is reminiscent of a rose, like a secret which only the initiated can penetrate, (hence the ancient term *sub rosa*: that which must remain secret). But is there any form of access to this incomparable, symbolic chapel? Possibly there may be one: through the old mines, connected under ground with the talayot and what it contains. The thought alone is fascinating: to know that there is something here we do not know, which Gaudí and his group did.

Above it there is a Calvary whose central cross is Christian, but with a pyramid on its vertical post, clearly a masonic touch, as is the cross of the Good Thief. The third cross is an arrow, and since Apollo is a key figure in the Park, this surely refers back to the Sun god, with his Sagittarian arrows sending lethal epidemics or alternatively giving life to the world.

The rose and the cross united make up the sign of the Rosicrucians, the name of the secret society created by the Protestant theologian J.V. Andreae, a German of the 17th century, and subsequently imported into Freemasonry. Eduardo Rojo, the Gaudianist, has rightly pointed out that Gaudí could have been a Rosicrucian, as certain of his works would seem to show, since by the close of the 19th century Catholic Rosicrucianism had made its appearance. And one of its founders was Josephin Péladan, who visited Barcelona in 1901. Could Péladan have failed to visit Güell and Gaudí? Of the Gaudian monuments that most clearly show the influence of the rose and the cross, the most striking are the sculptural entrances to the staircase in the La Pedrera, clearly visible from the Passeig de Gràcia.

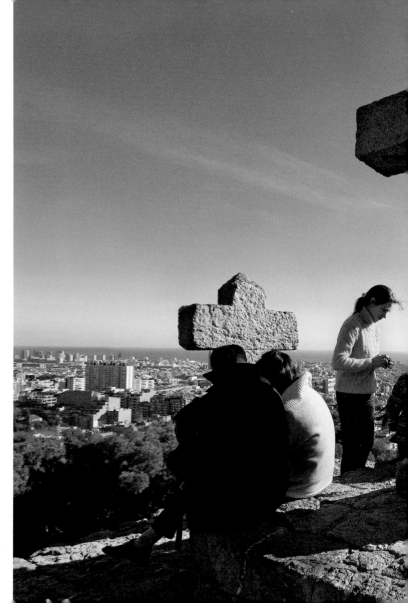

THE THREE CROSSES OF THE
CALVARY. THE CENTRAL CROSS
LOOKS TOWARDS THE
MOUNTAIN OF MONTJUÏC

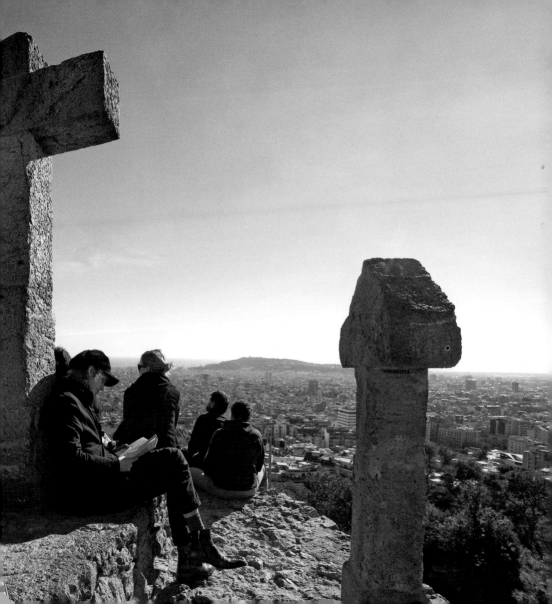

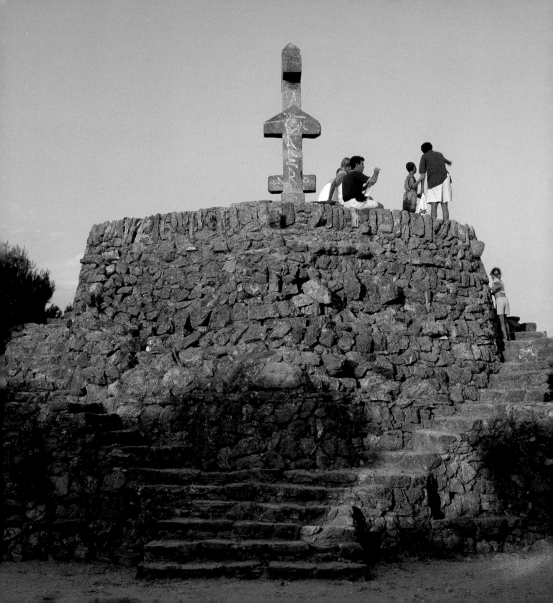

NEWEST ATLANTIS

Utopia

Influenced by utopian socialism, which also had followers in Reus, the adolescent Gaudí dreamed up a project with two friends for the then abandoned abbey of Poblet, and as a young man was a member of the *Cooperativa de Mataró,* a socialist organisation and the first of its kind in Spain. Güell, less radical, created the workers' housing scheme for the Güell factory as a social-humanist experiment. It is hardly to be wondered, then, that both were interested by works such as Plato's *Republic,* Aristophanes' comedy *The Assembly of Women* on what is effectively a communist utopia, the works of Saint John Chrysostom, quoted by Gaudí, and in all probability those of Campanella and Andreae. Nor is it a coincidence that More's *Utopia* should be translated into the Catalan language by Pin i Soler, Güell's secretary. According to Miquel d'Esplugues, Güell's chaplain, the latter's ambition was to create a "patriotic utopia out of the philanthropic works he undertook in his life".

But the book *New Atlantis* (1627) by Francis Bacon, must have been of especial interest, because of the admiration they felt for the famous poem *Atlantis* by their friend Jacint Verdaguer, and because Bacon's work is in agreement with all their moral ideas as idealistic right wing reformers. Gaudí referred to *New Atlantis* in making the following observation: "Bacon said that the experimental method would produce great riches and well-being; the first of the two assertions is true, because all advances and improvements come from the workshops, but not the second, as riches in themselves lead to misery and thus we see that the richest cities contain the most abject misery". That is, Gaudí was interested in utopias and placed science and experimentation among the highest objectives of human activity, but combined with social action that would improve the lot of individuals and groups, by means of

FROM ONE SIDE, THE 3 CROSSES LINE UP VISUALLY, FORMING A SAGITTARIAN ARROW AND CROSS

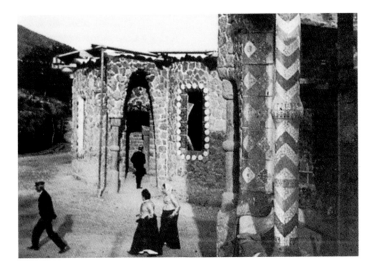

art, culture and economic means. As examples of this he referred to the *Orfeó Català* choir and the *Biblioteca de la Dona* (Women's Library)[3].

Bacon's utopia set out to achieve this and much more besides. New Atlantis is an imaginary island, ruled by a Christian king, where private property and social classes continue to exist, in a walled, isolated and independent city, with humanitarian laws, safety regulations, and a meticulous system of defence against epidemics. And, as its central activity, the experimental study of the nature of things and their workings, and the pursuit of the universal man. All this to be carried out by the Brothers of Solomon who govern the community and reveal or conceal scientific learning as they see fit, according to the common good. The fraternity organises journeys abroad to learn what is being done in different countries of the world, in arts, technique, inventions, etc. and calls the messengers traders in light, since "We trade not for gold, silver, jewels (...) but only to acquire the first thing that God created, which was light – to have knowledge of the development of all that there is in the world". Finally the work lists an impressive

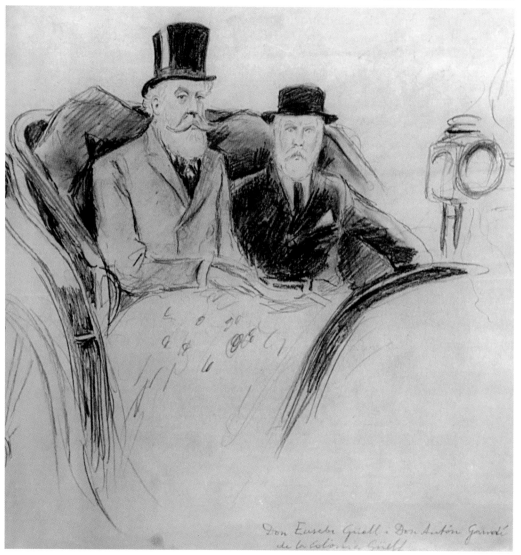

Don Eusebi Güell. Don Antón Gaudí
de la colonia Güell

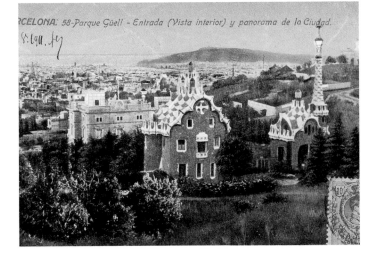

?CELONA: 58-Parque Güell - Entrada (Vista interior) y panorama de la Ciudad.

COLOURED POSTCARD FROM 1911

number of tasks carried out by the brotherhood, along with notes on the occult movements of things, initiation, wizards, the Sons of the Widow, the rites, etc. Parallels between the Park and the Island are therefore considerable, and all the more so given its strategies, economic protectionism included (Güell and his father were well-known protectionists). The idea of trading in light reinforces and deepens what has been said about the temple and commerce, and even more so the ideals of tolerance and application of science for the good of the entire world.

The objectives set for Park Güell were articulated in the deeds for the sale of the plots: beauty, recreation, hygiene, and health, guaranteed by the presence of Güell himself and his family in the Park. Anything that might be contrary to these principles was prohibited, and the estate was provided with infrastructure which would do great credit to builders even today, not to mention the security provided by a small detachment of the Civil Guard, paid for out of Güell's pocket.

This *Novísima Atlántida* (newest Atlantis) created by Güell, Gaudí and Trías, was to be a house of Salamonic wisdom, of science, and better yet, because of the moral implications, of learn-

ing that would call people to work in all fields. This explains still more Gaudí's reference to the seats of learning, since masonry is the *school of life* [23] where there is access to occult wisdom, directed by masters, more exactly, venerable masters. Lastly, Gaudí's plans for organising the 14 builder *masons* who worked on the site into a sort of guild, was on the same lines.

From all that we have said up to this point, it can be imagined that the community project would be masonic in its structure. Bacon's connection with the masonic brotherhood and the Rosicrucians is well known. In the frontispiece of his treatise on immunology, Güell inserted the Latin sentence: "All that has to do with humanity is my business" [5], and Hiram's children, according to Krause, "are the only historical institution that has as their aim and reason for being the cultivation of mankind in its pure and full humanity" [23]. The Park would thus be a lodge, with a women's section, whose members would meditate in the seclusion of their rooms, and perhaps occasionally in the caves in the square. And they would hold their assemblies in the Temple, before the images of the sun and the moon, with the symbolic objects prescribed by ritual – the mallet, compass, set square, but, no less, the cross. Dressed in their uniforms, they would gather on one or two evenings a month, and during the two great annual festivals of the summer and winter solstices, as well as on other occasions. But even though in the lodge to which Güell, Gaudí, Trias and Jujol belonged there would be no imposed vow of obedience, it would adhere to the masonic Catholic catechism and follow the debates under discussion, as is evident from what was said about the Red Sea. This would of course be adapted to the particular ideology of these anything but typical masons, who had found the way to dovetail together the doctrines, practices and symbols of the Sons of the Widow with those of Mary, keeping the essential ideas of the order: belief in one God, brotherly love, freedom of conscience, the search for truth through study, tolerance, the material, moral and intellectual improvement of humanity, as well as dedication to philanthropic activities. And it certainly is true that both persuasions upheld the ideal of work as ethics put into practice. It is extremely

significant that Gaudí, like a good mason, not only built but financed the School for Children of the Temple of the Sagrada Família.

Masonic secrecy was essential for the Logia Labor (Work Lodge). Over the altar in the parish church of *Sant Joan Despí* there is an inscription by Jujol in large letters, where the central word is *laboratores*, with labor written in bold. And two anecdotes serve to underscore still further the secrecy of the brotherhood: Jujol had drawn a seal in the form of a spiral for the parish of the Sagrada Familia, and some commented that the text was illegible. Whereupon Gaudí snapped: "Seal comes from *sigillum*, which means 'in secret'"[22]. On another occasion

he was even more explicit. The prelate Vidal i Barraquer was being shown round the Sagrada Familia by Gaudí and Jujol and, at a certain point he said to the latter: "You are Gaudí's disciple". Gaudí was quick to retort: "Not my disciple, my brother"[22].

SAGRADA FAMÍLIA PARISH SEAL

Oddly, once the triad had come together in the Park, with other brethren such as Jujol and Picó i Campanar living outside the walls, no other buyers came forward, despite the enormous attraction of living next door to Güell, the richest man in the principality of Catalunya, for the price that could be paid by a lawyer or architect, and in the Barri de la Salud – the neighbourhood with the greatest concentration of economic and social power in the city. We have to take it that these men wanted to be alone on their island or, more probably, that they would prefer being alone to being in the wrong company. Or perhaps better still, that the group was bound together by such decisive ties that anything else was of secondary importance and, for Güell, of little importance in economic terms, since he had other irons in the fire which gave him all the wherewithal he needed and more. Güell distinguished clearly between what he did for money and what he did for creativity. But it was precisely

ALCHEMISTS' SALAMANDER
(M.MAIER, "ATALANTA FUGIENS")

the philosophical and religious conditions required of the prospective buyers who came into the office at the Palau Güell which made the thing unacceptable, as became clear after they'd been skilfully examined by Picó i Campanar – the author of the poem on work.

The objective of this "Catholic lodge" could not be other than Work, carried out for themselves and for the good of humanity. Dedication to this secret Work in religion, philosophy, art and civic life, more than overcame the contradictions that sprang up in the way, such as the conflict between religious and social principles.

Eclecticism

Over the course of this volume, the text and photographs have also sought to show the different architectural styles that exist side by side in the Park, beginning with the four defined groups of styles, reworked by Gaudí: the refuge in the crypt, with its Catalan Romanesque style; the steps in the Baroque style of the turn of the 18th century; the Doric temple; and talayot from the Balearic Islands from pre-Roman times.

In addition to these there are Gaudí's own personal touches, such as the outer wall, the entrances and gates, the pavilions, the crenelations, the cistern, the theatre with the undulating bench and the porticoed wall, the three united Porticoes and the three viaducts on their different levels. And lastly, the sculptures: coats of arms, mushrooms, alchemic animals, plafonds, tripods, rosaries and crosses. And, in keeping with all of these, the free and imaginative representations of natural phenomena, such as the sun and the moon, the cataclysms, and the symbolic stones, the stone palm trees, etc. In the creation of these things Gaudí was the incomparable master, assisted by his colleagues in architecture and other arts.

In the Park, too, there are constructions that reflect the spirit of primitive religions, the Celtic druids; the Greek and Roman gods, and all present day religions from Hinduism, to Judaism and Christianity, the latter

"MOSES AND THE BRONZE SNAKE" (DETAIL) -PIERRE SUBLEYRAS- 1727. MUSÉE DES BEAUX-ARTS DE NÎMES

in turn comprising Catholicism, Protestantism and Anglicanism. Well represented, too, are esoteric doctrines and practices, such as spiritual alchemy, Lutheran or Catholic Rosicrucianism, and above all masonry of the integral Humanist order, the trunk from which stem so many branches of the ancient wisdom.

The writer Juli Vallmitjana said, in 1910, that the works of Gaudí are a demonstration of "the disorientation in religious beliefs at the present time" [14]. Whether this was true or not, everything leads us to the conclusion that Gaudí's works are essentially eclectic, even in his mature period, and above all in the Park Güell. This is so both from the artistic and religious points of view, despite its powerful kernel of brilliant originality, capable as it was of absorbing all he did. To put it positively: "The eclectic architecture of the 19th century is the most direct, honest, clear and ingenious architecture of humanity in all the history of that art." [21].

It is hoped that these hints will help initiate the visitor into a better conceptual and artistic understanding of the Park, as its creators wished, and enable them to attain a higher degree of knowledge and mastery.

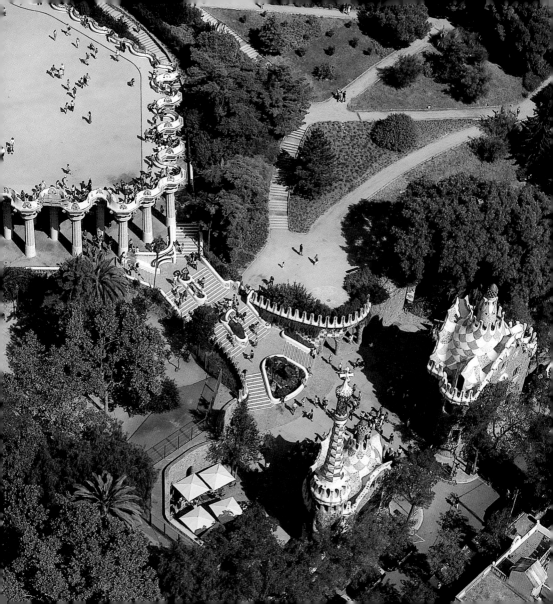

234

ENTRANCE PAVILIONS

CROSS SECTION OF THE ENTRANCE
PAVILIONS, WHERE ONE CAN SEE THE
UNUSUAL STRUCTURE OF ITS INTERIOR SPACE

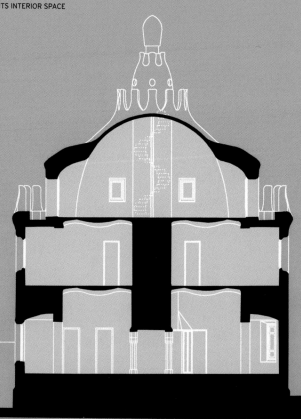

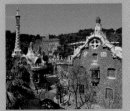
1 - ENTRANCE PAVILIONS

2 - CARRIAGE SHELTER

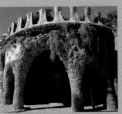
3 - STAIRWAY

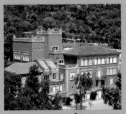
4 - CASA GÜELL

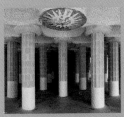
5 - COLONNADE

6 - J. M. JUJOL'S PLAFONDS

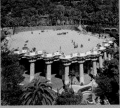
7 - SQUARE

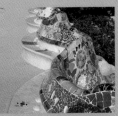
8 - UNDULATING BENCH

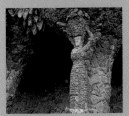
9 - THE WASHERWOMAN

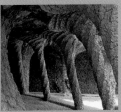
10 - PORCH OF THE WASHER-
WOMAN

11 - GAUDÍ HOUSE-MUSEUM

12 - LOWER VIADUCT

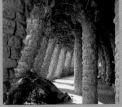
13 - CENTRAL VIADUCT

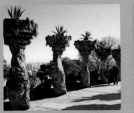
14 - UPPER VIADUCT

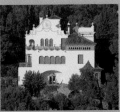
15 - CASA TRIAS

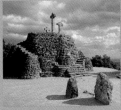
16 - CALVARY

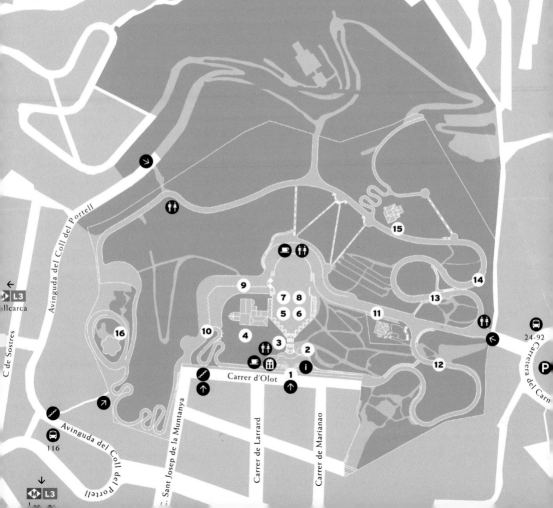

PARK GÜELL

BIBLIOGRAPHY

Park Güell, most accessible publications
1. Kent, C. / Prindle, D. *Hacia la Arquitectura de un Paraíso. Park Güell.* Madrid, 1992. There is an English language edition, 1993.
2. Rojo, E. *Antoni Gaudí, aquest desconegut: El Park Güell.* Barcelona, 1986.
 – *Antonio Gaudí, ese desconocido: El Park Güell.* Barcelona, 1987.
 – *El Park Güell. Historia y simbología.* Barcelona, 1997, abridged edition of the above in Spanish and English.

Writings by Gaudí, Güell and their circle
3. Gaudí, A. *El pensament de Gaudí,* his writings and observations collected by Puig i Boada. Barcelona, 1981.
4. Sellés, S. Information provided by Gaudí: *El Parque Güell. Memoria descriptiva.* Barcelona, 1903.
5. Güell, E. *L'immunité par les leucomaïnes.* Paris, 1889.
6. Esplugues, P. Miquel d'. *El primer Comte de Güell.* Barcelona, 1921.
7. Picó i Campanar, R. *Garraf.* Lyric poem. Barcelona, 1911.

Standard works
8. Bergós, J. A. *Gaudí, l'home i l'obra.* Barcelona, 1954.
9. Casanellas, E. *Nueva visión de Gaudí.* Barcelona, 1956.
10. Martinell, C. *Gaudí. Su vida, su teoría, su obra.* Barcelona, 1967.
11. Ràfols, J. F. *Antonio Gaudí.* Barcelona, 1929.

Other publications
12. Bassegoda Nonell, J. *El gran Gaudí.* Sabadell, 1989.
13. Bohigas, O. *Reseña y catálogo de la arquitectura modernista.* Barcelona, 1983.

14. Cirici Pellicer, A. *El arte modernista catalán*. Barcelona, 1951.

15. Flores, C. *Gaudí, Jujol y el Modernismo catalán*. Madrid 1982.

16. Garrut, J.M. *Génesis del Parque Güell*. Barcelona, 1971.

17. Lahuerta, J.J. *Antoni Gaudí. Arquitectura, ideología y política*. Barcelona, 1992.

18. Matamala, J. *Antonio Gaudí: mi itinerario con el arquitecto*. Barcelona, 1965 (unpublished).

19. Molema, J. *Antonio Gaudí, un camino hacia la originalidad*. Torrelavega, 1992.

20. Pane, R. *Antonio Gaudí*. Milano, 1964.

21. Torii, T. *El mundo enigmático de Gaudí*. Madrid, 1983.

22. Rafòls, J.F. / Flores, C. / Jujol, J.M. Jr., *La arquitectura de J.M. Jujol*. Barcelona, 1974.

Publications on related topics

23. Álvarez Lázaro, P. *La masonería, escuela de formación del ciudadano*. Madrid, 1996.

24. Carandell, J.M. *La Pedrera. Cosmos de Gaudí*. Barcelona, 1992.
 – *El teatre de la salud i la filantropia*, Butlletí dels Mestres. Barcelona, 1994
 – *El restaurant de les 7 Portes*. Barcelona, 1989 (About the mason Xifré).
 – *Las Utopías*. Barcelona, 1973.

25. Cassard, A. *Manual de masonería*. Barcelona, New York, 1871.

26. Castellanos, J. *Literatura, vides, ciutats*. Barcelona, 1997.

27. Gautier, H. *Histoire de Nîmes*, (1724). Nîmes, 1991.

28. Ginebra, J. *El grup modernista de Reus i la llengua catalana*. Reus, 1994.

29. Huertas Clavería, J.M. / Fabre, J. *Tots els barris de Barcelona. La Salut.*Barcelona, 1976

30. Ribas Seix, A. *Restauració del pavelló de consergeria del Park Güell*. Estudios Gaudinistas. Barcelona, 1996.

31. Sànchez Ferré, P. *La maçoneria a Catalunya. 1868-1936*. Barcelona, 1990.

32. Taxil, L. *Los misterios de la francmasonería*. Barcelona, 1887.

© 2007, TRIANGLE POSTALS

© TEXT
Josep M. Carandell

© PHOTOGRAPHY
Pere Vivas
Pere Vivas / Juanjo Puente, pages 2, 14, 43, 58, 88, 100, 144, 194, 209
Pere Vivas / Ricard Pla, pages 52, 53, 54, 55
Pere Vivas / Ricard Pla / Juanjo Puente, page 148
Pere Vivas / Josep Palet, page 84
Ricard Pla, pages 44, 49, 51, 126, 140, 160
Juanjo Puente, pages 171, 182, 183, 211, 218
Jaume Serrat, page 57
Josep Liz, page 94
© Ricard Opisso, VEGAP, Sant Lluís, 2005 (page 225)

DESIGN
Joan Colomer

LAYOUT
Mercè Camerino

TRANSLATION
David Sutcliffe, Eurolink, Barcelona

COLOUR SEPARATIONS
Tecnoart

PRINTED BY
NG Nivell Gràfic, Barcelona
5-2007

REG. NUMBER
B. 39.134 - 2005

ISBN
978-84-8478-117-2

ACKNOWLEDGEMENTS
Our grateful thanks to: Ajuntament de Barcelona: Centre d'Interpretació del Park Güell, Institut Municipal de Parcs i Jardins, Institut Municipal d'Història, Ajuntament de Reus, Càtedra Gaudí, Escola Baldiri Reixac, Musée Archéologique de Nîmes, Musée des Beaux-Arts de Nîmes, Museu d'Història de la Ciutat, Museu Pau Casals, Montserrat Albet, Josep Maria Brunet, Mercè Camerino, Juli Carandell, Luis Carandell, J. M. Huertas Clavería, Ignacio de Lecea, J.J Lahuerta, Trini Ortega Roca, Carme Osta, Ricard Pla, Lluís M. Potron, Anna Ribas, Assumpta Rosés.
Josep M. Carandell in particular wishes to make it known that this book was only possible thanks to the generous and constant assistance of Pere Vivas.